This book provides a general introduction to the work of the Pre-Raphaelite Brotherhood, and to that of their friends and associates. It explores both their art and their ideas and, by studying the way in which the Brotherhood itself came to be formed, attempts to pinpoint the particular qualities that underlay their originality; discusses too how much their aims were a crystallization and synthesis of ideas current in the mid-nineteenth century world of art.

While the central paintings of Rossetti, Hunt and Millais—executed between 1848 and 1852—are considered in some detail, the contributions of the less well-known members and associates of the Brotherhood are also examined. A final section traces the Brotherhood's influence through the later years of the nineteenth century and relates it to the Aesthetic Movement and Art Nouveau.

An Oxford graduate, John Nicoll is currently working as an editor in a publishing house.

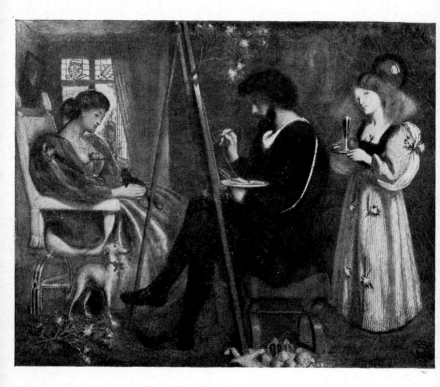

Simeon Solomon *The Painter's Pleasaunce* 1861
Watercolour $10\frac{1}{8}'' \times 13\frac{1}{8}''$ Whitworth Art Gallery, University of
Manchester

The Pre-Raphaelites

John Nicoll

General Editor David Herbert

Studio Vista/Dutton Pictureback

For Frances

© John Nicoll 1970
Designed by Gillian Greenwood
Published in Great Britain by Studio Vista Limited
Blue Star House, Highgate Hill, London, N.19
and in the United States of America by E. P. Dutton & Co., Inc
201 Park Avenue South, New York, NY 10003
Set in 11pt Bembo
Made and Printed in Great Britain
by Richard Clay (The Chaucer Press) Ltd, Bungay Suffolk
SBN 289 79783 7 (paperback)
SBN 289 79784 5 (hardback)

Contents

1 John Everett Millais *Cymon and Iphigenia* 1848
45″ × 58″ Coll. Lord Leverhulme (Photo Royal Academy)

1 Origins

In the middle decades of the nineteenth century the spirits of romanticism and philosophic idealism, which had permeated European thought since the late eighteenth century, were joined by a new sense of the importance of scientific inquiry, and were gradually superseded, at least among the *avant garde*, by an interest in scientific determinism which, it was hoped, would elucidate once and for all some of the eternal truths. These conflicting ideals were the central concern of most intellectuals and artists, and the story of the Pre-Raphaelite Brotherhood is to a considerable extent the history of their conflict and corruption among one small group of artists and their adherents.

In 1848 there was a revolution in every major country in Europe. In England the revolutionary fervour manifested itself most dramatically in a series of Chartist demonstrations, and among the sympathetic observers of one of these, the great procession from Russell Square to Kensington Common, were two young art students, John Everett Millais (1829–96) and William Holman Hunt (1827–1910), who had each just delivered a painting to the Royal Academy for its summer exhibition. *Cymon and Iphigenia* (1) was a brilliant essay in the style of Etty (2), then considered one of the greatest living artists. Its fluid, loosely modelled forms are derived ultimately from the paintings of Rubens, and the Roman and Bolognese masters of the sixteenth century, and only the uncompromising frontality of the composition gives any indication of Millais' dissatisfaction with the current fashion. Hunt's *Eve of St Agnes* (3) was more prophetic. The carefully observed detail, the interest in the effects of light, the awkward pose of the drunken reveller in the foreground—a difficulty created only to be overcome—and the use of Keats' then little-known poem as a basis for the painting were all features characteristic of later Pre-Raphaelite paintings.

2 William Etty *The Judgement of Paris* 1826
70″ × 107½″ Lady Lever Art Gallery, Port Sunlight

3 William Holman Hunt *The Eve of St Agnes* 1848
30½″ × 44½″ Guildhall Art Gallery, London
(Photo R. B. Fleming and Co.)

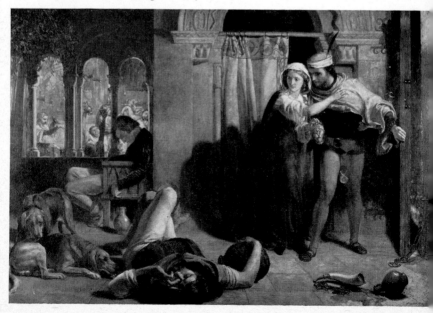

A month earlier, in March, Dante Gabriel Rossetti (1828–82), also an art student and already an accomplished romantic and mystic poet, had admired a painting of *Wycliffe Reading his Translation of the Bible* (4) by Ford Madox Brown (1821–93), and had asked Brown to take him as a pupil. Brown, though English, had been born in France and had studied in Belgium, France and Italy, only returning to England in 1844. His earlier work displayed a lively interest in the effects of natural light (86) but had mainly consisted of florid exercises in the Belgian romantic manner. *Wycliffe*, however, had been begun after his return from a visit to Rome where he had met, and admired ('one could not see enough of it', he wrote) the works of the Nazarenes—a brotherhood of German artists who had worked together in Rome since 1810 with the intention of regenerating religious art by imitation of the early Italian and German Masters. The hall-marks of Nazarene art (5, 6)—clarity of colour and outline, balanced and formalised composition, directness of appeal and

4 Ford Madox Brown *Wycliffe Reading his Translation of the Bible to John of Gaunt in the Presence of Chaucer and Gower* 1848
$47\frac{1}{2}'' \times 60\frac{1}{2}''$ City Art Gallery, Bradford

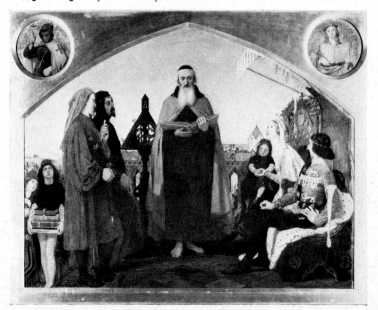

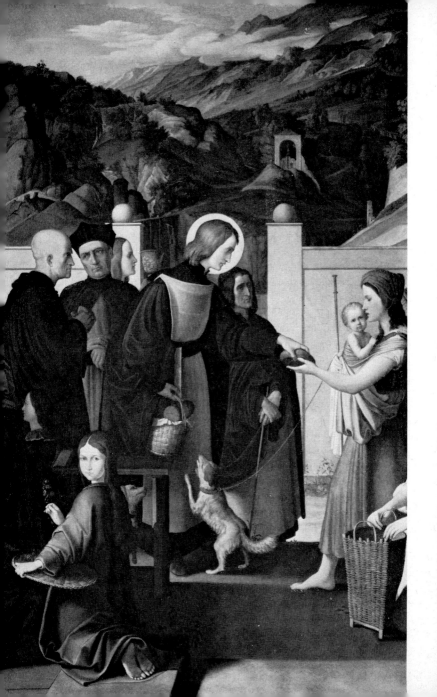

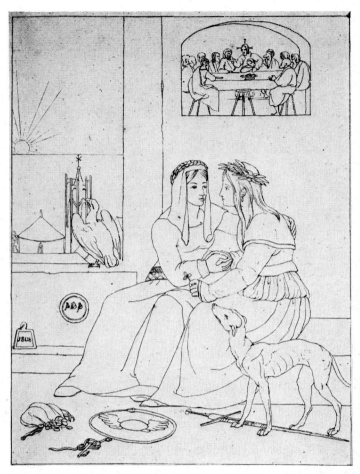

6 Franz Pforr *Allegory of Friendship* 1808
Pen and ink, approx 10″ × 8″ Städelsches Kunstinstitut, Frankfurt

5 Julius Schnorr von Carolsfeld, detail from *St Roch distributing Alms*
1817
Museum der Bildenden Künste, Leipzig

simplicity of sentiment are all reflected in Brown's work (8). The Nazarenes were Catholics and it is not insignificant that Brown, familiar with the writings of Pugin and the Ecclesiologists, should have turned to subjects of an openly (7) or implicitly Catholic nature at this time. Rossetti having been accepted by Brown as his pupil was initially to produce religious paintings in a clearly Catholic context (9, 10).

8 F. Madox Brown, study for *Chaucer at the Court of Edward III* 1845
Pencil, $12\frac{7}{8}$ " × $9\frac{1}{4}$" City Museum and Art Gallery, Birmingham
A study done in Rome for the final painting (1851), now in the Art Gallery of New South Wales, Sydney.

7 F. Madox Brown *Jesus Washing Peter's Feet* 1852–6
$46″$ × $52\frac{1}{4}″$ Tate Gallery, London

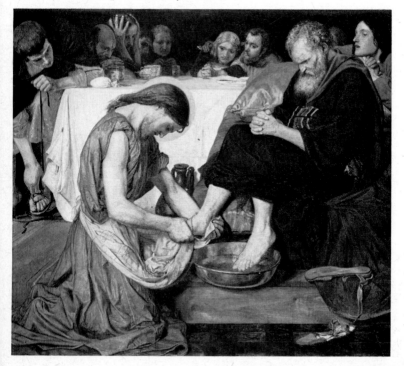

8

9 Dante Gabriel Rossetti *The Girlhood of Mary Virgin* 1849
$32\frac{3}{4}'' \times 25\frac{3}{4}''$ Tate Gallery, London

10 D.G.Rossetti *Ecce Ancilla Domini!* (*The Annunciation*) 1850
$28\frac{5}{8}'' \times 16\frac{1}{2}''$ Tate Gallery, London

In the course of the summer of 1848 Rossetti, Hunt and Millais became friends, and the mercurial Rossetti, tiring of the rigid artistic discipline imposed by Brown, soon moved in with Hunt who introduced him to the writings of Keats and Ruskin, and painstakingly supervised his first major painting (9). The three were at that time all members of a number of student's literary and artistic societies, and it was not surprising nor in itself significant that, together with some other friends at a meeting in Millais' house, they should have decided to found another in the autumn of that year. It was to be called Pre-Raphaelite, in honour of those Italian artists who had worked before Raphael and who had, they believed—for none of them had ever been to Italy—achieved a purity and a dignity in their work which the visual arts had never since attained. Having looked through a volume of Lasinio's engravings of the fourteenth-century frescoes in the Campo Santo at Pisa, they determined, wrote Hunt, 'that a kindred simplicity should regulate our own ambition, and we insisted that the naïve traits of frank expression and unaffected grace were what had made Italian art so essentially vigorous and progressive until the showy followers of Michelangelo had grafted their Dead Sea fruit on to the vital tree'.

The Pre-Raphaelite revolt was no less confused and ill-defined in its aims than many another, but it was primarily directed against the complacent artistic establishment 'which had for its ambition Monkeyana ideas [Landseer], Books of Beauty, and Chorister Boys whose forms were those of melted wax with drapery of no tangible texture'. The conventional pyramidic composition, the dramatic chiaroscuro light effects and open brushwork of Wilkie, Landseer and Etty (11, 12, 2) derived through Reynolds from Rembrandt and the Italian Masters of the sixteenth and seventeenth centuries were now contemptuously dismissed as 'slosh'.

11 Sir David Wilkie *Josephine and the Fortune Teller* 1837
83″ × 62″ National Gallery of Scotland, Edinburgh

The revolt, however, was more than just a rejection of current convention. The Pre-Raphaelites adopted and developed a number of ideas about the nature and purpose of art then current, of which the 'Early Christian' reversion of the Nazarenes was only one. Since the early years of the nineteenth century there had been a growing interest all over Europe in the art which had preceded the culminating achievement of the High Renaissance Masters—Raphael, Leonardo and Michelangelo. In the 1840s, under the influence of books like Rio's *Poetry of Christian Art* (1836, first French edition), Lindsay's *Sketches of the History of Christian Art* (1847) and Mrs Jameson's *Poetry of Sacred and Legendary Art* (1848), the interest grew and developed. 'Only by studying the primitives,' wrote Lindsay, 'their purity, innocent naïveté, childlike grace and simplicity, their freshness, fearlessness and utter freedom from affectation, their yearning after all things truthful, lovely and of good report can art become great again.' Charles Kingsley review-

12 Sir Edwin Landseer *The Challenge* 1844
38" × 83" Coll. The Duke of Northumberland
Compare with *The Scapegoat* (72)

ing Mrs Jameson referred to the praise which the young gave to 'the sweetness, the purity, the rapt devotion and the saintly virtue which shines forth from the paintings of Fra Angelico'. Symptomatic of this interest (and specifically of the interest of Prince Albert) was the decision in 1843 that the newly rebuilt Houses of Parliament should be decorated with frescoes in the manner of the fourteenth and fifteenth centuries. It was initially proposed that Overbeck—the most celebrated Nazarene—should be asked to do the job, but in the end a competition was held among British artists, and it was to enter for this that Brown had returned to England. Other artists besides Brown, and artists of stature and reputation, had been infected by the Nazarene 'Early Christian' spirit; in England the works of Herbert (13), Mulready (14) and Dyce (15) and in France those of Ingres (48) and Flandrin (49), can be seen in many respects as precursors of the Pre-Raphaelites, and were indeed acknowledged as such in varying degrees by the Brotherhood.

13 John Rogers Herbert *The Youth of Our Lord* 1856
32″ × 51″ Guildhall Art Gallery, London (first version 1847)
(Photo R. B. Fleming and Co.)
Herbert, a friend of Pugin and Etty was a Roman Catholic. Compare with *Christ in the House of his Parents* (28).

14 William Mulready *The Sonnet* 1839
14″ × 12″ Victoria and Albert Museum, London
An early example of the technique of painting over a white ground
to add luminosity to the colours.

15 William Dyce *Virgin and Child* 1838
29¾″ × 20½″ Castle Museum and Art Gallery, Nottingham

Clarity of line and purity of colour in emulation of fifteenth-century Italian art, however, is only one of the characteristics of Pre-Raphaelite art to be found in the work of its predecessors. A respect for scrupulous accuracy in matters of historical and scientific fact was a dominant characteristic of the progressive intellectual world of the mid-nineteenth century, and artistically this was reflected all over Europe in a new interest in 'realism'. In England the most notable examples of this trait were the meticulous still lives of William Henry Hunt (16), and the Eastern genre scenes of J.F.Lewis (17)—a Pre-Raphaelite *avant-la-lettre* as Ruskin pointed out in his defence of the Brotherhood when it came under attack. Ruskin's relationship to the Pre-Raphaelites is enigmatic and the position has been confused by the hindsight of the participants. His influence in the early years,

16 William Henry Hunt *Bird's Nest and Hawthorn* c 1850
Watercolour and gouache $8\frac{1}{8}'' \times 11\frac{1}{8}''$
Whitworth Art Gallery, University of Manchester

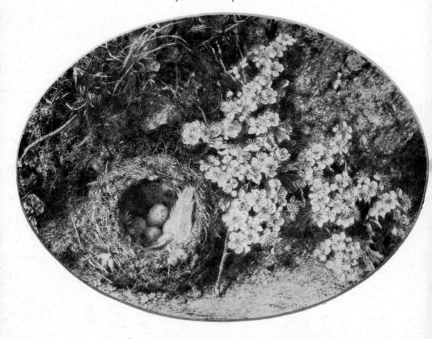

however, was undoubtedly great. Hunt had sat up all night in 1847 to read his *Modern Painters* (Vol. I, 1844) and had thought it written 'expressly for him'. It is a spirited but complex essay on Turner, nature and the aims and capacities of art. References to 'the burning messages' of Cimabue and Giotto, to 'tricks of chiaroscuro' which are 'not worthy of the name of truth' and to the 'vicious English taste' which can enjoy 'nothing but what is theatrical' and which seeks as the highest good 'brilliancy and rapidity of execution' clearly struck a chord in the young Hunt. Ruskin's development of the Lockean philosophy that ideas (which man shares with God) are nobler than senses (which he shares with beasts) and that therefore the greatest picture is that with the greatest number of great ideas, profoundly influenced the Pre-Raphaelites and indeed much subsequent nineteenth-century art.

17 John Frederick Lewis *The Hhareem* 1850
Watercolour $18\frac{1}{2}''\times 26\frac{1}{2}''$ Victoria and Albert Museum, London

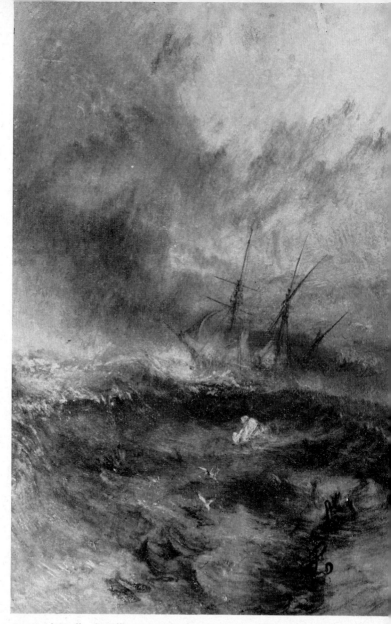

18 Joseph Mallord William Turner *Slavers Throwing Overboard the Dead and Dying—Typhoon Coming on (The Slave Ship)*, 1840
$35\frac{3}{4}'' \times 48''$ Museum of Fine Arts, Boston, Henry Lillie Pierce Fund

In *Modern Painters* (Vol. I) Ruskin wrote that 'if I were reduced to rest Turner's immortality upon any single work, I should choose this.' The following year his father gave it to him.

In a celebrated and much quoted passage Ruskin urges young artists to make Turner's latest works (18) their object of emulation and to 'go to Nature in all singleness of heart and walk with her laboriously and trustingly, having no other thoughts but how best to penetrate her meaning and remember her instruction; rejecting nothing, selecting nothing and scorning nothing; believing all things to be right and good, and rejoicing always in the truth. Then when their memories are stored and their imaginations fed, and their hands firm, let them take up the scarlet and gold, give reins to their fancy and show in what their heads are made of '. The relationship of Turner's *Slave Ship* to the Pre-Raphaelites is not at first glance clear, but to contemporaries familiar with the sombre and easy pictures of Wilkie and Landseer it would have had much in common in its brilliance of colour and its uncompromisingly vivid representation of natural phenomena. One of the group's severest critics was to refer to Turner as 'the chief Pre-Raphaelite', and it is important to stress that the meticulous reproduction of natural detail was not only something that the Pre-Raphaelites did not initiate, but that to some contemporaries it was hardly a central component of Pre-Raphaelitism at all. Truth to nature, as Turner had demonstrated and as the Impressionists were to demonstrate again, is not only achieved by a quasi-photographic fidelity to the observed facts.

The third strand of contemporary artistic thought which the Pre-Raphaelites were to develop was the painting of 'problem' pictures with a direct relevance to the contemporary scene. Paintings like *Work* (89), *The Awakening Conscience* (Coll. The Trustees of Sir Colin and Lady Anderson), *Found* (52) and *The Stone Breaker* (32) dealt directly with political and social problems, subjects which few artists in England since Hogarth had been prepared to treat realistically and uncompromisingly, although the increasing incidence of pictures on social themes in the 1840s and early 1850s—some even with titles like *The Awakened Conscience* (R.A. 1849 and 1853)—indicates that the Pre-Raphaelites were to some extent only developers of an existing trend. While some later Victorian followers were to lapse into sentimentality or sensationalism when dealing with such themes, these social-realist pictures must be numbered along with the works of Goya, Géricault and Courbet among the progenitors of twentieth-century political art.

2 The Brotherhood

There were seven members of the Pre-Raphaelite Brotherhood (it was Rossetti who suggested they adopt the collective noun then fashionable among revolutionary bands in Italy, whence his father had been exiled for subversive activities). The Nazarenes too had formed a Brotherhood, but their explicitly monastic and evangelical intentions, reflected in their chosen patron St Luke, were not shared by the Pre-Raphaelite Brotherhood. Though Hunt, Millais and Rossetti were the three most interesting and artistically gifted of the group, three others produced work more tentative and less original, but by no means to be despised. James Collinson (1825?–81) painted at least three significant Pre-Raphaelite pictures (19, 20, 26) before the combined consequences of his obsessive and melancholy religiosity and an unhappy love affair with Rossetti's sister Christina, drove him to resign from the Brotherhood in 1850 and to seek solace in a monastery.

19 James Collinson *Italian Image Makers at a Roadside Alehouse* 1849
 31″ × 43″ On the London Art Market 1969

20 James Collinson *The Renunciation of Queen Elizabeth of Hungary* 1851
$47\frac{3}{8}'' \times 71\frac{1}{2}''$ Art Gallery, Johannesburg

The story of the Queen's reception into the Monastery of Kitzingen was told by Charles Kingsley in *The Saint's Tragedy*, 1848.

Thomas Woolner (1825–92) was primarily a sculptor, but not, initially, a successful one. His attempts to convey in sculptural terms the austere linearity and direct naturalism of Pre-Raphaelite paintings were not commercially successful, and when his designs for the Wordsworth Memorial (21) were rejected in 1852 he left England to prospect in the Australian goldfields. But he remained a member of the Brotherhood, and long composite letters incorporating portraits of the other brethren were sent to him in Australia. Failing as a miner, he turned once again to sculpture and in 1854 returned to England where he quickly became an accomplished but conventional portrait sculptor. Only a design for an unexecuted Cawnpore memorial gives any indication of the lasting influence of Pre-Raphaelite ideas on his work (22).

F.G.Stephens (1828–1907) was less talented, and clearly knew it, for he produced few paintings and most of them are painfully laboured and contrived. After 1850 he ceased to paint altogether and became an art critic, and only his unfinished *Mort d'Arthur* (23) gives any indication that he might have developed into a fluent and expressive artist.

W.M.Rossetti (1829–1919), Gabriel's brother, was never an artist at all, but a critic. To Stephens and him must be given some of the credit for the movement's popular success, as they both bestowed praise on its products from influential positions as art critics of *The Athenaeum* and *The Spectator*. They participated in the production of the Brotherhood's short-lived magazine *The Germ*, and both made substantial contributions to the later mythology of Pre-Raphaelitism by publishing lengthy accounts of the movement and its participants. No other comparable artistic movement indeed is as lavishly or as misleadingly documented as Pre-Raphaelitism. Substantial accounts of the movement, and their part in it, were left by all the main protagonists, or have been compiled since by their children or followers. To sort out what seems to have been the truth from the frequently conflicting evidence (often coloured by the wisdom of hindsight) is no easy task.

21 Thomas Woolner, model for *The Wordsworth Memorial* 1852
Woolner had designed the *Wordsworth Medallion* in Grasmere Church the previous year but his project for the *Memorial* was never executed. Whereabouts unknown.

22 Thomas Woolner, model for *The Cawnpore Memorial* 1861
Not executed: whereabouts unknown

23 Frederick George Stephens *Mort d'Arthur* c 1849
13¾″ × 28¾″ Tate Gallery, London

The first public manifestation of Pre-Raphaelitism was at the Royal Academy exhibition in the spring of 1849, and at the Free Exhibition slightly earlier in the same year. The first four paintings, all signed with the mysterious monogram PRB, were exhibited and were favourably received. Hunt's *Rienzi* (24) and Millais' *Lorenzo and Isabella* (25) were hung together as pendants and noted by the *Art Journal* (one of the two or three most important and influential artistic papers) as 'admirable' works in the Early Italian manner—a category in which 'we have this year seen more essays ... than we have ever before remarked'. *The Athenaeum* praised the 'ability and spirit' of the painters, but first voiced a criticism which was later to be repeated and developed by the Brotherhood's detractors. Deprecating Millais' 'absurd mannerism' in showing one of Isabella's brothers kicking

24 W. Holman Hunt *Rienzi Vowing to obtain Justice for the Death of his Brother* 1849
34″ × 48″ Coll. Mrs E.M.Clarke (Photo Royal Academy)
The subject is from Bulwer Lytton's *Rienzi, The last of the Tribunes.*

her dog—a gesture which seems now to epitomise one of the most Pre-Raphaelite characteristics of the picture, the desire to startle, to make no concessions to what was conventionally regarded as good taste, 'to touch' as Madox Brown later put it, 'the Philistine on the raw'—the reviewer went on to criticise 'that inlaid look, that hard monotony of contour and absence of shadow . . .'. *Rienzi* is of interest as an early example of *plein-air* naturalism, but its stilted composition and the ungainly and unrelated poses of the principal figures makes a strong contrast to the powerful and fluently organised images of Millais' *Isabella*. Here the subtle but easy rhythm of the diners' heads and the savage kick of the brother in the foreground both lead the eye to the unfortunate lovers on the right, whose hopeless passion is deftly and poignantly conveyed.

25 J.E.Millais *Lorenzo and Isabella* 1849
40½″ × 56¼″ Walker Art Gallery, Liverpool
The subject is from Keats' *Isabella or the Pot of Basil.*

Also at the Academy, though passed over by the reviewers, was Collinson's *Italian Image Makers* (19). Its colours were not as striking as those of its companions, but in its minutely observed detail and its ambiguous subject matter (apparently a straight-forward representation of a contemporary scene, but possibly with religious and even Catholic overtones) it is a characteristic Pre-Raphaelite painting.

Rossetti's first Pre-Raphaelite picture *The Girlhood of Mary Virgin* (9) had been exhibited a month earlier at the Free Exibition. It too had been painted direct from nature, and like Millais he had used members of his immediate family as models. It was favour-ably received, and Rossetti noted with satisfaction that he had seen the critic of the *Art-Union* stand in front of it for a full fifteen minutes. Although this, and Rossetti's second major Pre-Raphaelite painting, *Ecce Ancilla Domini!* (10), are directly derived from the work of the Nazarenes through Madox Brown, and though they are arguably the only two of all the Pre-Raphaelite paintings which really seek to reinterpret the vision of fifteenth-century artists like Fra Angelico (Rossetti had planned to turn *The Girlhood* into a tryptych by adding wings), it is interesting to note in this first picture so many of the character-istics of his subsequent paintings. The claustrophobic composition with the foreground separated by a physical barrier from the background, the multifarious literary images, the lush, oppressive atmosphere conveyed by the lavish vegetation, and the two sonnets composed for the occasion and fixed to the frame, are devices which reappear in nearly all his later work.

No one, it seems, noticed or remarked the enigmatic initials added to the signatures and all the paintings were bought from the exhibition for prices between £80 and £170; sums then worth perhaps ten times their present value. A year later, how-ever, the secret was revealed by a gossip columnist, probably as a result of Rossetti's indiscretion, and in 1850 the Brotherhood's paintings were greeted with an almost hysterical contempt and derision by reviewers determined to rebuke what they con-sidered to be the arrogance of the Brotherhood, and to repulse its presumed Romanist and reactionary tendencies.

26 James Collinson *Mother and Daughter; Culver Cliff, Isle of Wight, in the distance* c 1849
$20\frac{3}{4}'' \times 16\frac{5}{8}''$ Coll. Mr and Mrs Paul Mellon

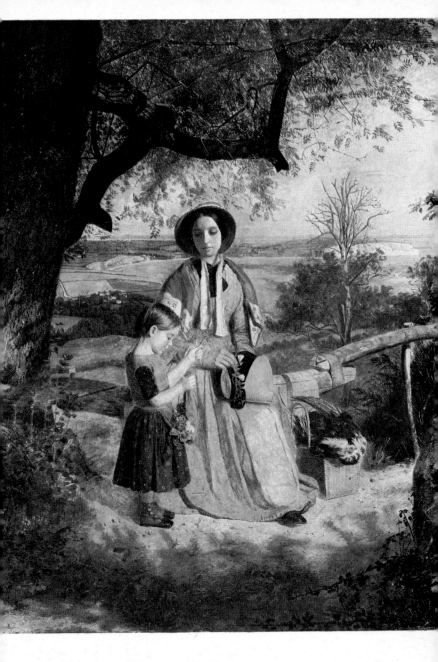

This assumption of an arrogantly reactionary intent was not of course altogether mistaken, and it may be that some critics were confirmed in their view by a perusal of *The Germ*, the spectacularly unsuccessful magazine, four issues of which the Brethren wrote and published in the first four months of 1850, and which they unsuccessfully hawked to the visitors outside the Academy. Although only about two hundred copies of each issue were sold the magazine was not a negligible affair. Subtitled 'Thoughts towards Nature', it was Gabriel's idea, and in it a number of his best-known poems were first published. It also included his extraordinary story 'Hand and Soul', a tale written, so his brother tells us, mostly in the five hours after midnight on 21 December 1849, about an imaginary thirteenth-century painter from Arezzo called Chiaro dell'Erma. Chiaro 'loved art deeply' and 'endeavoured from early boyhood towards the imitation of any objects offered in nature' until, as a result of this 'extreme longing after a visible embodiment of his thoughts', he felt faint 'in sunsets and at the sight of stately persons'. He clearly reflected Rossetti's own longings for love, for art, and for the discovery of his spiritual self which he was later to find personified in Lizzie Siddal, his model, and ultimately his wife. As Rossetti was to do, Chiaro loved a mystical, virginal and impalpable lady whose hair was 'the golden veil through which he beheld his dreams'. The story ends when she appears to the despairing Chiaro and tells him to paint her, for 'I am an image, Chiaro, of thine own soul within thee'. Chiaro does so, and 'his face grows solemn with knowledge', for his goal has been achieved.

It is not perhaps without interest that Gabriel's own attempt to make an etching of Chiaro painting his embodied soul to illustrate the story was a failure, and the plate was destroyed without any impressions being taken from it. One at least, however, of the illustrative etchings for the *Germ*, Hunt's *My Beautiful Lady* and *Of My Lady in Death*, two subjects etched on one plate to accompany two poems by Woolner, is of the highest quality, and foreshadows much of the fine book and magazine illustration of the Pre-Raphaelites and others in the 1860s. Burne Jones was later to describe it as 'truly a song without words' (27).

With the exception of Millais, all the Brotherhood and a number of their associates, including Madox Brown, wrote poems and articles, or made etchings for the *Germ*. They were literary

27 W. Holman Hunt *My Beautiful Lady* and *Of My Lady in Death* 1849
$7\frac{7}{8}'' \times 4\frac{3}{4}''$
Two etchings on one plate. The frontispiece to the first issue of the
Germ, accompanying two poems by Thomas Woolner.

men, and the Pre-Raphaelite Brotherhood was only one of the societies to which they each belonged. Rossetti's letters tell of frequent gatherings under different auspices, and though the Brotherhood was certainly paramount, the peculiar importance with which it has been vested by posterity would perhaps have seemed inappropriate at the time. Until, that is, the Royal Academy exhibitions of 1850 and 1851.

'Mr Millais' principal picture (28) is, to speak plainly, revolting,' wrote *The Times* critic of the 1850 exhibition. 'The attempt to associate the Holy Family with the meanest details of a carpenter's shop, with no conceivable omission of misery, of dirt, of even disease, all finished with the same loathsome minuteness, is disgusting.' Charles Dickens repudiated 'the great retrogressive principle' of the 'mean, repulsive and revolting' pictures of the Brotherhood in a violent review in *Household Words*. 'You behold the interior of a carpenter's shop. In the foreground . . . is a hideous, wry-necked, blubbering, red-headed boy, in a bed-gown,

28 J.E.Millais *Christ in the House of his Parents* (*The Carpenter's Shop*)
1850 34″ × 55″ Tate Gallery, London

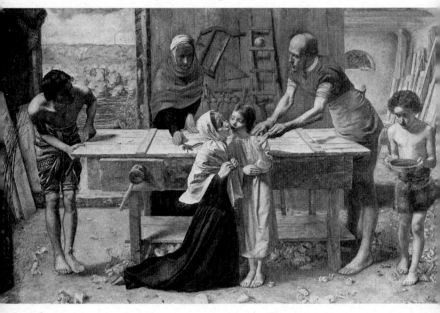

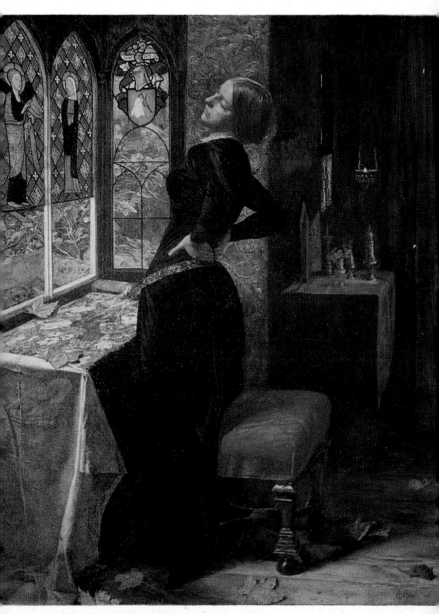

29 J.E.Millais *Mariana* 1851
23½″ × 19½″ Coll. Lord Sherfield (Photo Rodney Todd White)

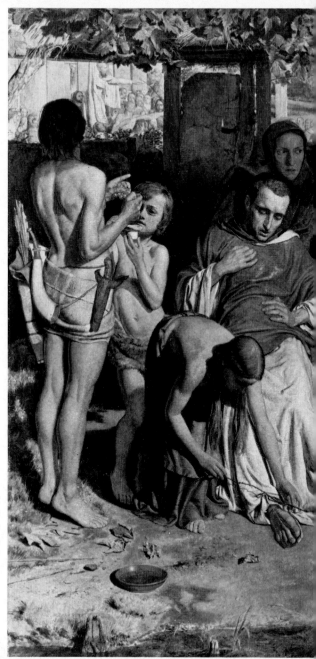

30 W. Holman Hunt
 A Converted British
 Family sheltering a
 Christian Priest from
 the Persecution of the
 Druids 1850
 $43\frac{3}{4}'' \times 52\frac{1}{2}''$
 Ashmolean
 Museum, Oxford

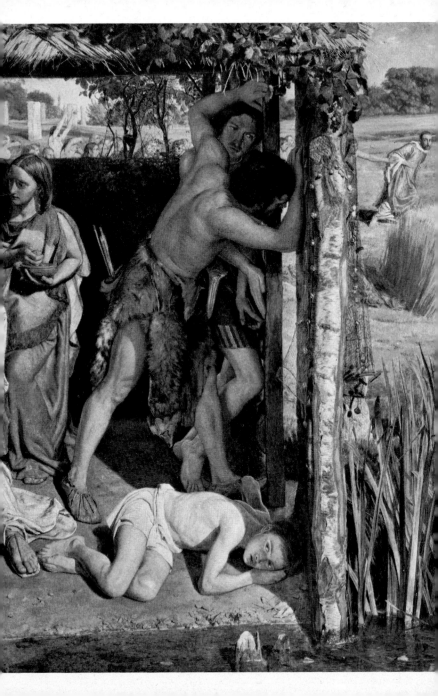

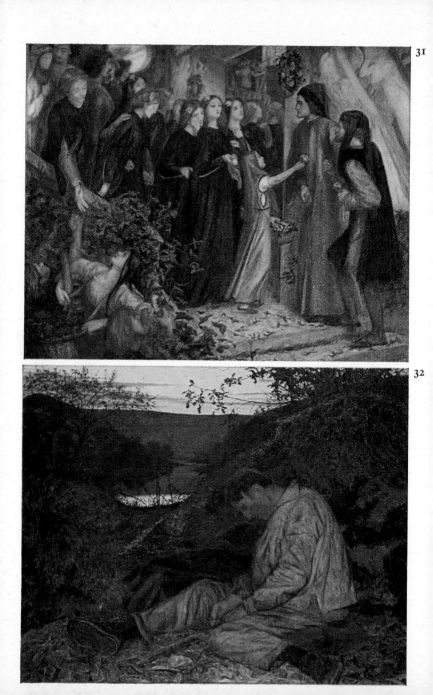

31

32

who appears to have received a probe in the hand, from the stick of another boy with whom he has been playing in an adjacent gutter, and to be holding it up for the contemplation of a kneeling woman so hideous in her ugliness, that, (supposing it were possible for any human creature to exist for a moment with that dislocated throat) she would stand out from the rest of the company as a Monster, in the vilest cabaret in France, or the lowest gin shop in England.' None of the other Pre-Raphaelite pictures (10, 30, 33) fared any better at the hands of the reviewers, 'Abruptness, singularity, uncouthness, are the counters with which they play for fame,' wrote *The Athenaeum*; but Millais'

31 D.G.Rossetti *Beatrice, meeting Dante at a Marriage Feast, denies him her Salutation* 1855
Watercolour $13\frac{1}{2}'' \times 16\frac{1}{2}''$ Ashmolean Museum, Oxford
A replica of the original watercolour of 1851. The subject is taken from the *Vita Nuova*.

32 Henry Wallis *The Stonebreaker* 1857
$25\frac{3}{4}'' \times 31''$ City Museum and Art Gallery, Birmingham

33 James Collinson *Answering the Emigrant's Letter* 1850
$27\frac{5}{8}'' \times 35\frac{7}{8}''$ City Art Gallery, Manchester

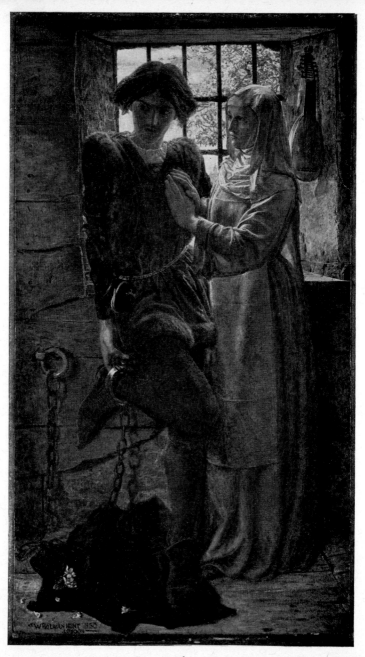

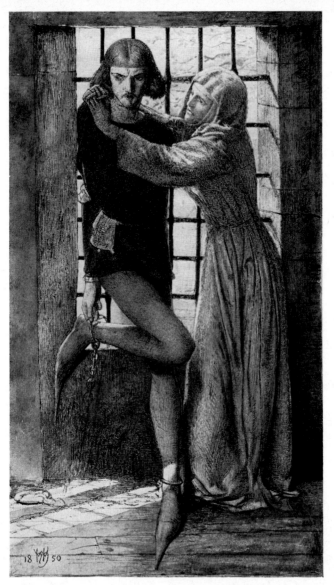

35 W. Holman Hunt, study for *Claudio and Isabella* 1850
Pen and ink and wash 12¼″ × 7¼″ Fitzwilliam Museum, Cambridge

34 W. Holman Hunt *Claudio and Isabella* 1850
29⅞″ × 16¾″ Tate Gallery, London
The subject is from *Measure for Measure*, Act III, scene I.

picture bore the brunt, since all manner of Catholic and Ecclesio-logical symbolism could easily be read into it—the sheep at the door, for example, and the symbols of the crucifixion and the Trinity on the back wall. All in fact, except Collinson's, were on explicitly religious themes, but it seems unlikely that there was any common or evangelical purpose behind them. Hunt's characteristically bold and wholly original composition had begun life as his entry for the Royal Academy Gold Medal the previous year, for which the set subject was 'An Act of Mercy, . . . with no less than two figures naked'. Millais' prefiguring of the crucifixion was apparently suggested to him by the text of a sermon, while Rossetti considered religious pictures to be 'the most worthy to interest the members of a Christian community'. Only when he found them to be 'not for the market' did he turn to Malory, Dante and Browning for subjects which initially at least he 'pitched on for their presumptive saleableness'.

The effect of the attacks on the Brotherhood was devastating. Neither Hunt nor Rossetti sold their pictures from the show as they had done the previous year, and it seems likely that Millais, who had previously negotiated the sale of his pictures, had to accept a lower price than that agreed. Mutual recriminations broke out, Rossetti vowed never to exhibit again in public, though he did not keep his resolution; Millais' parents, hurt that their brilliant son should be publicly disgraced, blamed the influence of Rossetti—'that sly Italian'; and Millais grimly re-marked to a friend that people had better buy his pictures now when he was working for fame than in a few years time 'when I shall be married and working for a wife and children'. Hunt, heavily in debt, with commissions repudiated and without the private means even to buy a new canvas, fell back on the charity of Augustus Leopold Egg and William Dyce, among the few Academicians prepared to support the Brotherhood. Dyce found him work restoring pictures for Trinity House, while Egg com-missioned his next painting, a scene from *Measure for Measure* (34). This was to be one of his most hauntingly beautiful and expressive works, and though not finished till 1853 it shows him first turning to the 'problem' subject—Claudio asking his chaste sister Isabella to yield to Angelo in order to save him from execution. The horror of the situation and the conflicting emotions of the participants are tellingly conveyed by the setting

36 C.A.Collins *Convent Thoughts* 1851
34″ × 24″ Ashmolean Museum, Oxford

and the understated gestures of the figures, though it is interesting to note how Isabella's rejection of her brother is more subtly indicated in the preliminary drawing (35) than in the final painting.

Though assailed on all sides by the professional critics, 1850 did in fact see the beginning of a gradual acceptance of the Brotherhood's views by outsiders. At least two pictures were painted according to their principles by men not members of the club, though closely acquainted with them (41, 85), and in the course of the summer Millais and Collins (1828–73) became close friends of Thomas Combe, Superintendant of the University Press at Oxford and for the first of many times stayed and painted together in his house. The dons, no conformists, were said by Millais to be great admirers of Hunt's *Druids*, and in late summer Combe bought it for £160. Combe and his wife were to be staunch and life-long friends and patrons of the Pre-Raphaelites —patrons not unlike the bourgeois and independent-minded men from Northern manufacturing towns who were to buy most of their later work, while the traditional aristocratic patrons contented themselves with blander and less adventurous offerings.

As well as finding the first major patron, it was Millais who, through his friend Coventry Patmore, enlisted the aid of *the* major art critic—Ruskin—when his, Brown's, Hunt's and Collins' paintings (8, 29, 36–9) were again denounced by reviewers in the following year. In two magisterial letters to *The Times* Ruskin castigated critics and public for failing to recognise in the 'finish of drawing and splendour of colour' of these 'admirable though strange pictures', the best works in the show. In a subsequent pamphlet and course of lectures he elaborated his opinion, and though not slow to criticise or take undue credit for their later works he remained for many years their most perceptive and sympathetic critic.

Although the colour harmonies of previous Pre-Raphaelite pictures had been notably vivid, Hunt's *Valentine and Sylvia* (39), and Millais' *Woodman's Daughter* (38) were the first pictures in which the technique of painting over a wet white ground was consistently employed. This procedure was derived from the newly revived technique of fresco painting, and a variant of it

37 J.E.Millais *The Return of the Dove to the Ark* 1851
$34\frac{1}{2}'' \times 21\frac{1}{2}''$ Ashmolean Museum, Oxford

had already been used by Mulready and others to give brilliance to their colours. Hunt and Millais had used it for details in their previous work, but here it was employed for the entire picture. On a canvas covered with dry white paint the portion of the picture to be painted in the course of the day was sketched. The drawing was then covered with fresh white paint just thinly enough for the drawing to show through, and over this the transparent colour was laid, so gently that the ground was not worked up. The effect was, and remains, astonishingly vivid, and it seems appropriate that the first official recognition of the artists' achievement should have been the award of the first prize to Hunt's *Valentine and Sylvia* at the Liverpool exhibition in the autumn of 1851; prophetic too, because Liverpool was soon to provide the Brotherhood with some of the most munificent of its patrons, and with some of the most talented and diligent of its followers.

Worldly success, however, coincided with the beginning of the gradual fragmentation of the Brotherhood. While Hunt had been working painstakingly out of doors in Surrey on the landscape background to *Valentine and Sylvia*, and Millais had been doing the same for *The Woodman's Daughter* in Wytham woods near Oxford, and for *Mariana* (29) in Merton College Chapel, Rossetti tried and failed to paint a landscape 'from nature'. Having read the whole New Testament in an unsuccessful attempt to find an original religious subject, he turned to Shakespeare, and in *Borgia* (40)—initially conceived as a scene from *Richard III*—produced what was to be the first of a whole series of finely wrought, mystical watercolours with subjects taken from mediaeval and Renaissance legends and literature. These watercolours of the 1850s have become associated in the public mind with Pre-Raphaelitism, for Rossetti was certainly the most colourful and attractive member of the group, but their romantic escapism was only one facet of the movement, and one which was shared with many of the Brotherhood's artistic contemporaries with whom they had otherwise little in common, and it could be argued that these magical little paintings are, to some extent, a rejection by Rossetti of his initial artistic impetus.

38 J.E.Millais *The Woodman's Daughter* 1851
 35″ × 25½″ Guildhall Art Gallery, London
 (Photo R. B. Fleming and Co.)
 The subject is taken from a poem by Coventry Patmore.

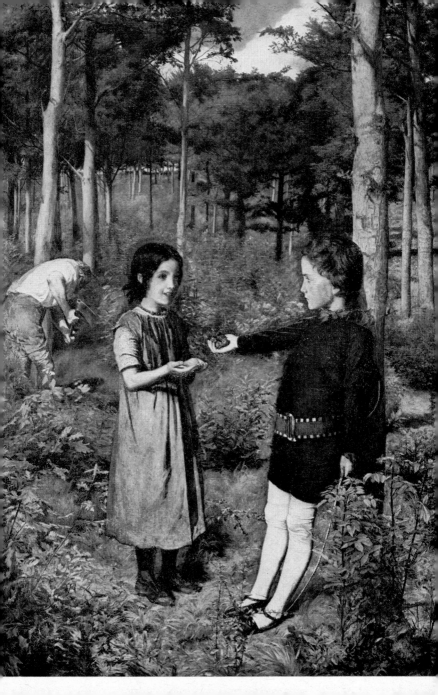

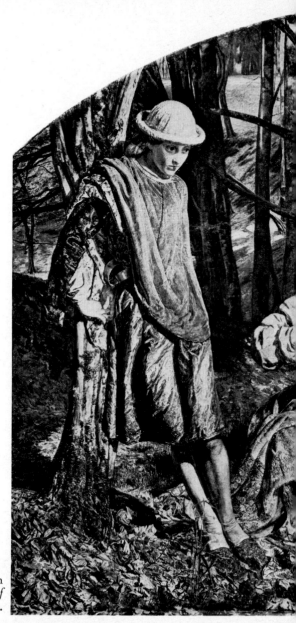

39 W. Holman Hunt
*Valentine rescuing
Sylvia from Proteus*
1851
$38\frac{3}{4}'' \times 52\frac{1}{2}''$ City
Museum and Art
Gallery, Birmingham
The subject is from
*The Two Gentlemen of
Verona*, Act V, scene 4.

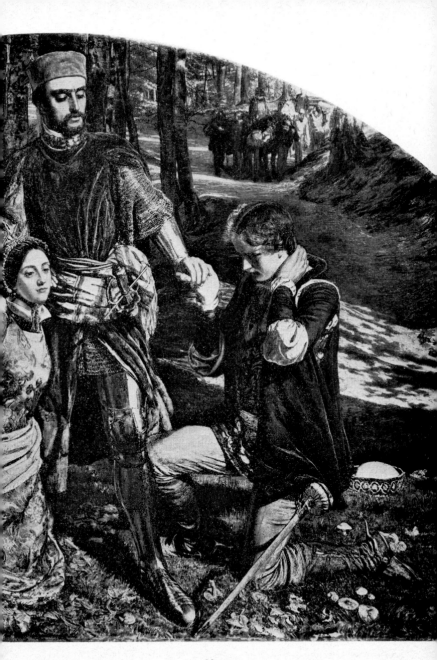

In the previous year Collinson had resigned from the Brotherhood, and Woolner was shortly to emigrate to Australia. William Michael Rossetti's Pre-Raphaelite Journal, a record of their meetings and doings, had lapsed to all intents and purposes by May 1851. The paths of the members were already beginning to diverge, and when in 1854 Hunt went on the first of his lengthy visits to the Middle East, only two months after Millais had been elected an Associate of the Royal Academy against which the revolt had been primarily directed, Rossetti wrote, 'the whole Round Table is dissolved'.

3 Dante Gabriel Rossetti

Of all the Pre-Raphaelites, Rossetti has, since shortly after his death, come to be regarded as the most important and influential. But the work which we now admire so much—the intimate and personal watercolours of the 1850s and early 1860s—were seldom exhibited in his lifetime, and little known except among a small circle of friends and patrons. It is not least the intensely personal nature of these works that makes them so much more attractive to us than the large late oils.

Rossetti's artistic technique betrays unmistakable evidence of his unsatisfactory artistic education. Lazy, impatient and mercurial he could seldom apply himself to one picture for long enough to bring it to a satisfactory conclusion. He abandoned Madox Brown as a teacher because he disliked the drudgery of the exercises which he had set him, and soon ceased to work with Hunt whose formidable powers of concentration and determination he quite lacked. Scarcely any of his work before about 1863 can honestly be said to be technically proficient except for his portrait sketches, mainly of Elizabeth Siddal (1834–62)—the mysterious, melancholy and beautiful 'angel with bright hair' whose features appear in so many Pre-Raphaelite pictures and who was Rossetti's constant companion and inspiration until her death in 1862. She was first seen by Rossetti's friend W.H. Deverell (1827–54) in a milliner's shop in 1849, and appears as Viola in his *Twelfth Night* (41). She posed for Millais as *Ophelia* (77) and for Hunt as Sylvia (39) but from Rossetti's work between 1852 and 1862 she is seldom absent, and again and again long after her death her features appear unmistakably in his paintings. Hunt tells us that initially Rossetti had no special relationship with her but after 1851 she sat to him exclusively; in 1860 they were married. She died, apparently of an overdose of laudanum, in 1862, and that date marks a dramatic turning point in Rossetti's art. The sensitivity and pathos of his numerous drawings of her are cumulatively an extraordinarily moving and graphically

40 D.G.Rossetti *Borgia* 1851
Watercolour $9\frac{1}{8}'' \times 9\frac{3}{4}''$ Bottomley Bequest, City Art Gallery, Carlisle

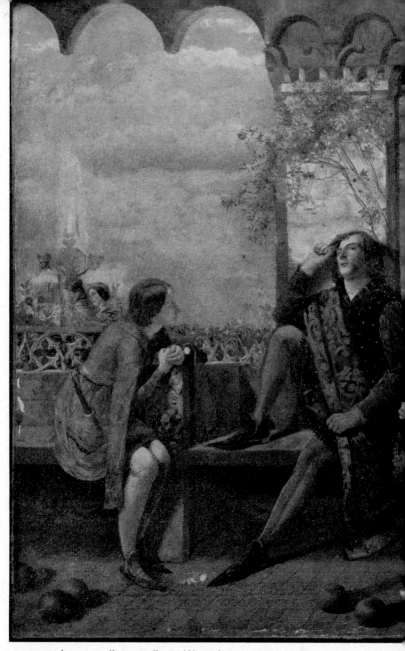

41 Walter Howell Deverell *Twelfth Night* 1850 40″ × 53½″

on loan to the Tate Gallery, London

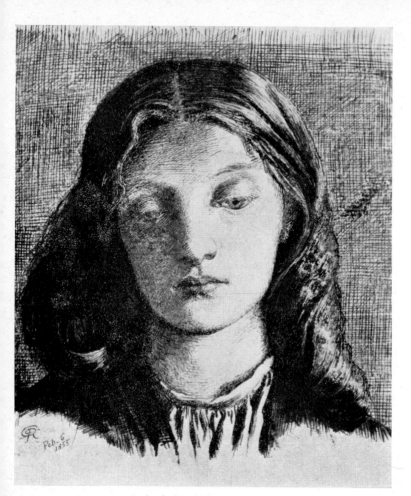

42 D.G.Rossetti *Elizabeth Siddal* 1855
Pen and ink $4\frac{3}{4}'' \times 4\frac{1}{4}''$ Ashmolean Museum, Oxford

impressive achievement (42, 43, 44, 45). Madox Brown noted in
his diary in 1854 that he called on Rossetti and saw 'Miss Siddal,
looking thinner and more deathlike and more beautiful and more
ragged than ever . . . Gabriel . . . drawing wonderful and lovely
Guggums [her nickname] one after another, each one a fresh

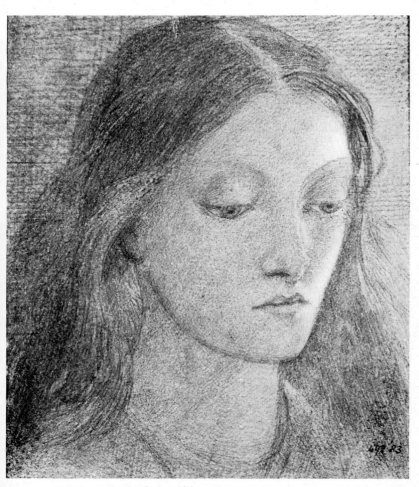

43 D.G.Rossetti *Elizabeth Siddal* c 1860
Pencil $4\frac{3}{4}'' \times 4\frac{1}{2}''$ Victoria and Albert Museum, London

charm, each one stamped with immortality'. And in August
1855 'Rossetti showed me a drawer full of 'Guggums'; God
knows how many ... it is like a monomania with him. Many of
them are matchless in beauty ... and one day will be worth
large sums.'

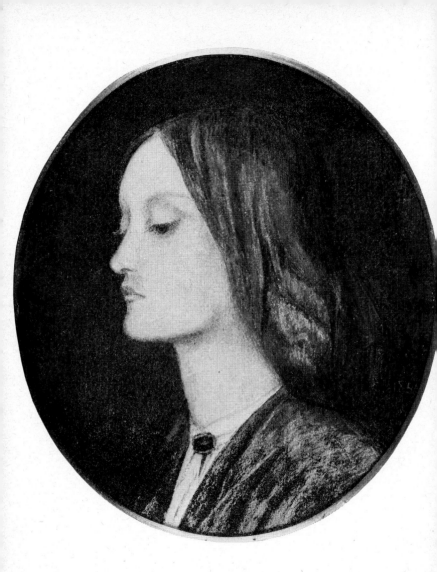

44 D.G.Rossetti *Elizabeth Siddal* 1854
Watercolour $8\frac{1}{2}'' \times 7\frac{3}{4}''$ Coll. Mrs Virginia Surtees

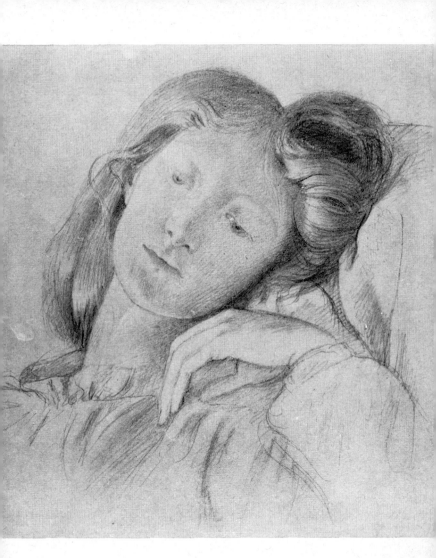

45 D.G.Rossetti *Elizabeth Siddal* c 1860
Pencil $9\frac{3}{4}'' \times 10''$ Fitzwilliam Museum, Cambridge

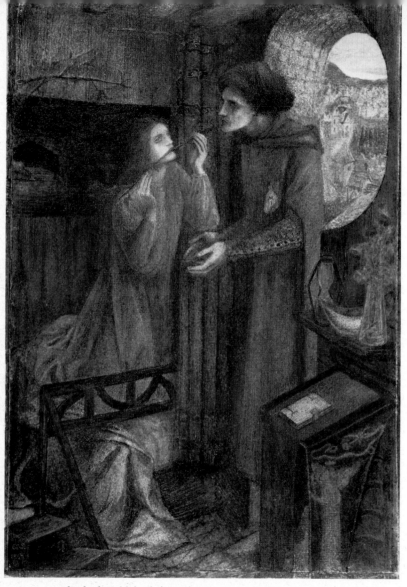

46 Elizabeth Siddal *Clerk Sanders* 1857
Watercolour 11″ × 7¾″ Fitzwilliam Museum, Cambridge
From the ballad *Clerk Sanders*; the eponymous hero importunes
Maid Margret to let him stay with her; she agrees, and he is slain by
one of her brothers.

Ruskin also, who became Rossetti's close friend in the course of the 1850s, fell under her spell and between them they encouraged her to paint. Though her paintings are technically even less satisfactory than Rossetti's they have exactly the same direct and personal appeal and, probably because of the extensive help which he gave her, are closely related to them in their subject matter, in their rich but subdued and subtle colouring, in their enclosed and cramped composition and in their powerfully felt evocation of the middle ages, dreamlike and idealised (46, 47).

47 Elizabeth Siddal *Sir Patrick Spens* 1856
Watercolour $9\frac{1}{2}'' \times 9''$ Tate Gallery, London
From the ballad; the wives of the drowned sailors lamenting on the shore.

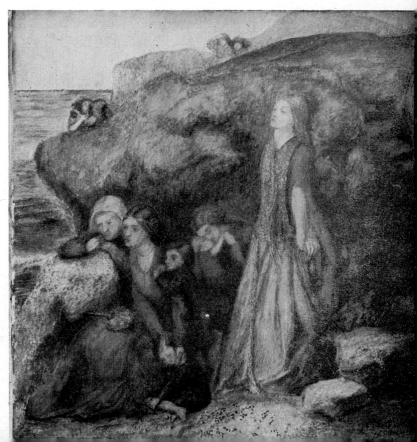

48 Jean Auguste Dominique Ingres *Ruggiero and Angelica* c 1839
$18\frac{3}{4}'' \times 15\frac{1}{2}''$ National Gallery, London
A smaller, but similar, copy of the version of 1819 seen by Rossetti in
the Louvre. From Ariosto's *Orlando Furioso*, Canto X

Rossetti never visited Italy and though his admiration for the work of the sixteenth-century Venetian Masters is evident in the rich and balanced colour harmonies of *St George and the Princess Sabra* (60) and *Beatrice denying Dante her Salutation* (31), specifically Italian motifs are absent from nearly all his work after 1850. In 1849, however, he had visited Paris and Bruges with Hunt. Apart from the work of the Venetians (Giorgione, Titian and Veronese) and the routine obeissance to 'several wonderful Early Christians whom nobody ever heard of' the paintings which he singled out for special approbation in his letters home were 'the miraculous works of Memling and Van Eyck', 'the ineffably poetical Mantegnas', 'the exquisite perfection of Ingres' *Ruggiero and Angelica*' (48) and the unfinished frescoes of the latter's pupil, Hippolyte Flandrin, in the church of St Germain des Près, which were, Rossetti and Hunt decided 'the most perfect works taken *in toto* that we have seen in our lives . . . Wonderful! Wonderful!! Wonderful!!!' (49)

49 Hippolyte Flandrin *Christ's Departure to Calvary* 1846
Fresco: St Germain des Près, Paris

Ingres and Flandrin had declared the same devotion to early Italian Art as did the Pre-Raphaelites. Flandrin was a friend and admirer of the Nazarenes, while Ingres as a young man and a pupil of David had been a member of a group of students who called themselves *les Primitifs*; (another member, Maurice Quay, in 1800 briefly styled himself as *Préraphaelite*). Of the fourteenth-century frescoes in the Campo Santo at Pisa, engravings of which had been admired at the first Pre-Raphaelite meeting, Ingres had said 'it is on one's knees that one should study these men', and it is not surprising that Rossetti should have admired some at least of his work. The sinuous line, the piercing clarity of vision and the meticulous finish were all effects after which Rossetti strove,

50 D.G.Rossetti *How Sir Galahad, Sir Bors and Sir Percival were fed with the Sanc Grael; but Sir Percival's Sister died by the Way* 1864
Watercolour $11\frac{1}{2}'' \times 16\frac{1}{2}''$
Tate Gallery, London
A version of a design originally conceived for the Oxford Union frescoes in 1857.

and which in his later work, though atmospherically overshadowed by a doom-laden and macabre exoticism, he increasingly often achieved (61).

The appeal of Flandrin is perhaps more surprising, and it is probably his naïve simplicity of expression and baldly two-dimensional composition which made the deepest impression. Resembling nothing so much as the mosaics of Ravenna (one of the earliest of all manifestations of early Christian pictorial art) his rhythmic lines of figures find echoes in Rossetti's *Sir Galahad Receiving the Sanc Grael* (50), and later in the work of Burne-Jones, but the influence of early Flemish art on the Pre-Raphaelites in general and on Rossetti and Hunt in particular

was more marked than that of Ingres and his pupils. The minuteness of detail, the coexistence of an enclosed foreground spatially related to the spectator, and a detailed, seemingly incidental yet profoundly important background, and the frequent presence of figures playing musical instruments, are familiar features of the paintings of Memling and Van Eyck, and all are to be found in Rossetti's work.

But it is to Blake that we must look for the prime source of the paintings to which Rossetti turned after the critical reception of his work done under the tutelage of Madox Brown and Hunt in 1848–50. In 1847 he had bought from Samuel Palmer's brother, a keeper at the British Museum, the notebook which the then virtually forgotten Blake had kept for over twenty years. In it were early drafts of many of his poems, and scathing judgements of artists like Rubens, Rembrandt and Correggio which must have deeply affected Rossetti. Worst of all, he wrote, were the paintings of Sir Joshua Reynolds 'the simpering fool', while Giotto and Dürer were singled out for praise. Blake's own paintings, and those of his brother Robert, many of which Rossetti knew through his friendship with Gilchrist, Blake's first biographer, are unmistakably related in atmosphere if not in iconographical detail to Rossetti's work in the fifties. The sensuous, sinuous linearity of the figures conceived as decorative motifs in their own right, the spatially compressed composition, the individuality of subject matter, and the carefully worked up detail are all common components.

If the sources are relatively straightforward, however, the development is not. After his two 'Early Christian' pictures of 1848–50 Rossetti began only two other pictures which can be described as Pre-Raphaelite in the sense in which the word was understood in the 1850s. *The Bower Meadow* (51) was begun in November 1850 as a scene from Dante. It was painted from nature in Knole Park near Sevenoaks where Rossetti was staying with Hunt who was at work on *Valentine and Sylvia*. That it was not finished until 1872, and then as quite a different subject, was characteristic of Rossetti. 'The cold here is awful when it does not rain,' he wrote from Sevenoaks to his friend Jack Tupper, 'and then the rain is awful'. Quite apart from the physical difficulties involved in painting from nature in England ('I had to sketch . . . without a hat, and with my umbrella tied over my

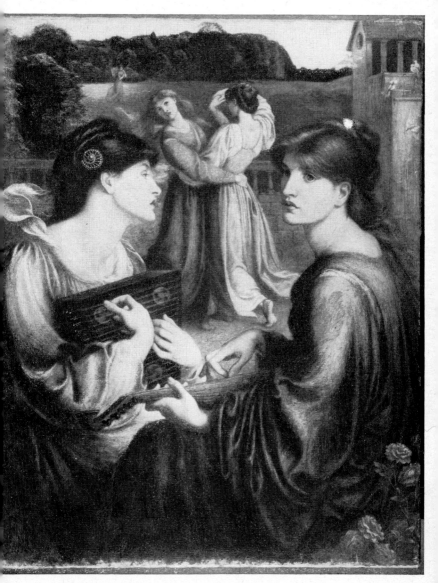

51 D.G.Rossetti *The Bower Meadow* 1872
$33\frac{1}{2}'' \times 26\frac{1}{2}''$ City Art Gallery, Manchester

head') which never deterred Hunt, Rossetti's aesthetic scruples prevented him from ever putting into effect wholeheartedly the theories of Hunt and Millais: 'The fact is, between you and me, that the leaves on the trees I have to paint here appear red, yellow etc to my eyes: and as of course I know them on that account to be really of a vivid green it seems rather annoying that I cannot do them so: my subject shrieking aloud for spring.'

Rossetti's fourth Pre-Raphaelite picture, *Found* (Wilmington, Delaware, was begun in 1854, though the earliest drawing dates from a year earlier, but it was still unfinished at his death in 1882, and was in fact the last picture that he ever worked on. A completed study (52) done in 1855 and inscribed with the characteristic explanatory text 'I remember thee—the kindness of thy youth

52 D.G.Rossetti, study for *Found* c 1855
Pen and ink 9¼″ × 8⅝″ City Museum and Art Gallery, Birmingham

53 D.G.Rossetti, study for *Borgia* (40) c 1850
Pencil 19⅛″ × 10⅜″ Coll. Mrs Virginia Surtees

54 D.G.Rossetti *The First Anniversary of the Death of Beatrice* 1849
Pen and ink 15¾″ × 12⅞″ City Museum and Art Gallery, Birmingham

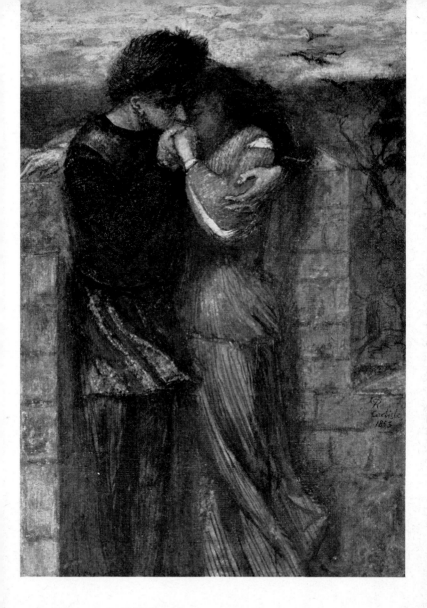

55 D.G.Rossetti *Carlisle Wall* 1853
Watercolour $9\frac{3}{4}'' \times 6\frac{3}{4}''$ Ashmolean Museum, Oxford

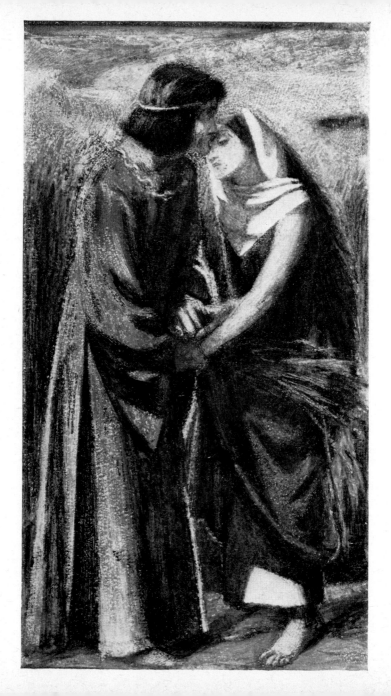

—the love of thy betrothal' gives an idea of its intended appearance and also shows his increasingly fluid draughtsmanship. It is still a long way from the florid mannerism of his late work, but equally distant from the disciplined and slightly stilted linearity of his drawings of around 1850 when the Brotherhood was closest (53, 54).

But if he never finished another truly Pre-Raphaelite canvas after *The Annunciation*, the water colours of the fifties on the 'chivalric, Froissartian themes' which had become, he confessed, 'quite a passion of mine' (55, 56, 57, 58, 59, 60) are a wholly original and overwhelming artistic achievement. So impressive indeed were they that through their influence on William Morris, Burne-Jones, Simeon Solomon and a host of lesser men, Rossetti's highly individual image of the middle ages came to be considered, quite misleadingly, as the Pre-Raphaelite stereotype. The theme of the helpless hopelessness of earthly love and the sense of the constant presence of death which pervade all his work of this period are of course common to most romantic painting and poetry, but it is in the uniquely expressive manner in which he visualised these themes that Rossetti's artistic originality and importance lies. A contemporary description of the *Wedding of St George and the Princess Sabra* (60) by Rossetti's friend and admirer James Smetham catches and crystallises this phase of his art.

56 D.G.Rossetti *Ruth and Boaz* 1855
Watercolour $12\frac{3}{8}'' \times 6\frac{7}{8}''$ Coll. Mrs Virginia Surtees

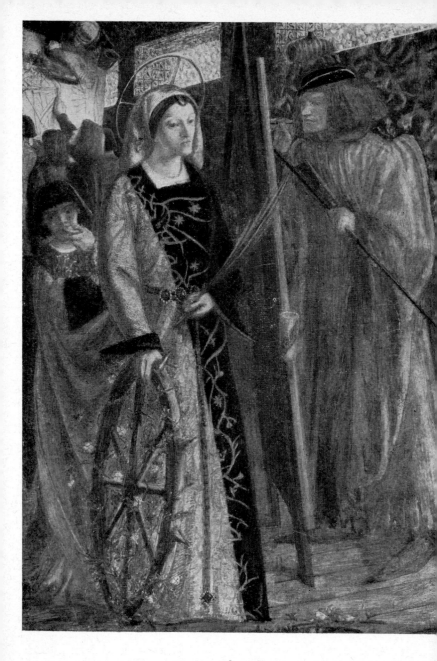

57 D.G.Rossetti *St Catherine* 1857
$13\frac{1}{2}'' \times 9\frac{1}{2}''$ Tate Gallery, London

58 D.G.Rossetti *The Chapel before the Lists* 1857–64
Watercolour $15'' \times 16\frac{1}{4}''$ Tate Gallery, London

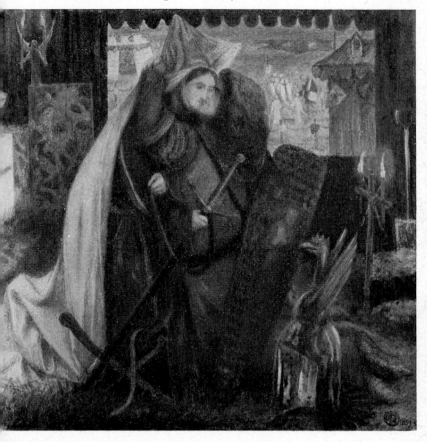

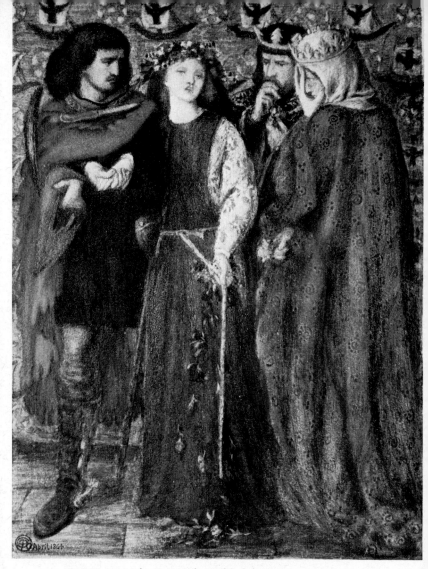

59 D.G.Rossetti *The First Madness of Ophelia* 1864
Watercolour $15\frac{1}{2}'' \times 11\frac{1}{2}''$ Art Gallery and Museum, Oldham
Though painted two years after Miss Siddal's death, she is clearly
recognisable as Ophelia. The pictorial formula is closely based on *La
Belle Dame Sans Merci* of 1855, now in an Italian private collection.

'*The Marriage of St George* is one of the grandest things, like a golden dim dream. Love "credulous all gold", gold armour, a sense of secret enclosure in "palace chambers far apart"; but quaint chambers in quaint palaces where angels creep in through sliding panel doors and stand behind rows of flowers drumming on golden bells, with wings crimson and green.

'There was also a queer remnant of a dragon's head which he had brought up in a box (for supper possibly) with its long red arrowy tongue lolling out so comically, and the glazed eye which somehow seemed to wink at the spectator, as much as to say "Do you believe in St George and the Dragon? If you do I don't. But do you think we mean nothing, the man in gold and I? Either way I pity you my friend."'

60 D.G.Rossetti *The Wedding of St George and the Princess Sabra* 1857 Watercolour $13\frac{1}{2}''\times13\frac{1}{2}''$ Tate Gallery, London

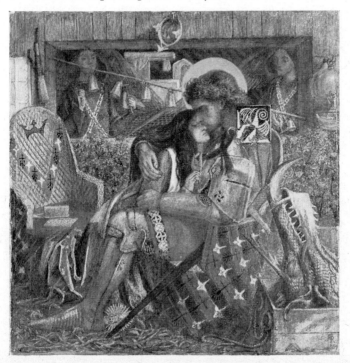

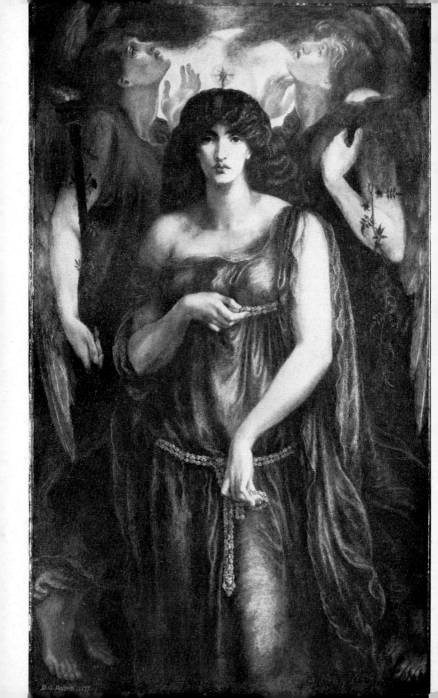

After Elizabeth Siddal's death in 1862 Rossetti's style changed abruptly and lost such Pre-Raphaelite characteristics as it had till then retained. His compositions remained crowded and to the end Rossetti could answer 'no' when the artist asked himself, as Ruskin said he must, 'Can my details be added to? Is there a curve [in my picture] which I can modulate . . . a vacancy I can fill?' His invention became more hectic and bizarre, the size of his pictures increased and his brushwork though more polished became looser and more generalised (61). His output rapidly and permanently changed from the intimate watercolours to the macabre, sensual and iconic ladies which he painted (often with the help of assistants) during the last twenty years of his life. These late paintings are not negligible achievements, and at the time indeed they were much more highly regarded than his early works. (*Astarte Syriaca*, for example, was sold for £2100 in 1875 while *St George and the Princess Sabra* had fetched only £40 at public auction in 1862.) Their most interesting feature, perhaps, lies in the development of the semi-abstract surface patterning which is apparent in his early work, but which now becomes an increasingly formal and stylised decorative device. One of the sources of Art Nouveau (and through that of twentieth-century abstract art) is to be found in these paintings.

61 D.G.Rossetti *Astarte Syriaca* 1877
72″ × 42″ City Art Gallery, Manchester
In common with many of Rossetti's large, late oils, this was exhibited with an explanatory sonnet.

4 William Holman Hunt

Hunt has been since his death and even before it, the most mis-understood, misinterpreted and maligned Pre-Raphaelite. The efforts of his widow to conceal his actions and opinions from the world, and the scarcely less energetic attempts of later writers to sensationalise them have served to render his character elusive, and to encourage derisively simplistic interpretations of his art. In fact, however, his forceful personality and the respect and affection which it commanded was the driving force behind the original Pre-Raphaelite movement; while his deeply felt and infinitely precious canvases, painted with all the passion of mediaeval manuscript illuminations, are among the most remarkable and powerful paintings produced in nineteenth-century England.

Born in 1827 of *petit-bourgeois* parents, life was never easy for Hunt. He was placed as a clerk at the age of twelve and a half and seldom received any parental encouragement in the pursuit of his chosen profession, which was necessarily confined to his spare time in his early years. He was frequently appallingly poor, and according to Burne-Jones, whose confidant he later became, lived for a time on a penny a day. Though these hardships were substantially confined to his early years, throughout his life his letters, though often spirited and amusing, bear witness to his constant self-doubt and inability to produce work which satisfied his own exacting and unvarying standards. 'I am tired!' he wrote to Stephens in 1853, 'Oh so tired! I wish I could rest, sleep or die from my wearing labour.' Ten years later the position had hardly changed. 'I am so weary of work! but I cannot get a holiday for a single day for I have not finished anything for so long . . . I *can't* get anything finished. I work and work till I feel my brain as dry as an old bit of cork, but completion slips away from me.' Even in 1882, at the height of his reputation, when he was able to command £10,000 for a single picture, the same desperate note is found in a letter to Burne-Jones: 'The bitterness of the struggle . . . to do what one dreamed in one's youth to be glory that all would have joy in, is indeed . . . hard to swallow . . . there is more and more ever behind one to make turning back more terrible . . . I should really have given up the picture

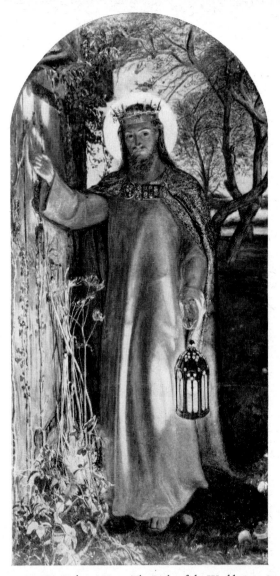

62 W. Holman Hunt *The Light of the World* 1851–6
19⅝" × 10 5⁄16" City Art Gallery, Manchester
A study for the larger picture now at Keble
College, Oxford, but finished afterwards.

[*The Triumph of the Innocents* (70)] but Millais came again and made light of the difficulty . . . one naturally says "yes, of course . . . it will come when touched again", but it won't come . . . if Tuesday fails I think I can trust myself to go no further.'

It is hardly surprising therefore, in view of the demands which his art made on his life that Hunt should paint such fundamentally serious pictures. Great art, he wrote, could only be achieved by incessant labour, but the reward would be correspondingly great, for a great painting would be the witness of the life and

63 W. Holman Hunt *May Morning on Magdalen Tower* 1890
62" × 80½" Lady Lever Art Gallery, Port Sunlight
Hunt wrote that 'for several weeks I mounted to the Tower roof about four in the morning . . . to watch for the first rays of the rising sun, and to choose the sky which was most suitable for the subject'.

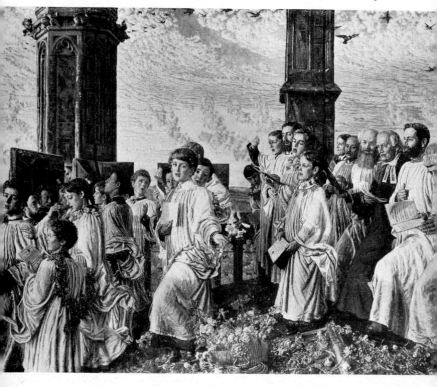

64 W. Holman Hunt *Morning* 1849
Pen and ink 6⅝″ × 13⅛″ Fitzwilliam Museum, Cambridge

individuality of a nation to all eternity, while the artist in his service as 'a priest in the temple of nature' was the only sure guardian of the essential moral values of humanist society.

Although Hunt brought to the Brotherhood qualities of sincerity, honesty and determination, and though he substantially organised the group while it functioned as a body, and was indeed sometimes addressed as President by the members, his work bore only a tangential relationship to that of his companions. The features which distinguish his paintings are their vividness of colour (71), their subtle and varied explorations of the effects of light (62), their gravity of content (72) and their wilful eccentricity of composition and design (30). It is not true to say, as is often asserted, that his style remained the same throughout his life, for though he painted meticulously detailed pictures on a white ground like *May Morning on Magdalen Tower* (63) as late as 1890, the totality of his output varied from early, linear and strongly Germanic drawings (64), through the most important and beautiful hard-edge pictures of the early 1850s (30, 34, 39, 71), to the freely handled and atmospheric landscapes of the 1860s and 1870s (65, 67) while in others the technique is almost *pointilliste* in its delicacy.

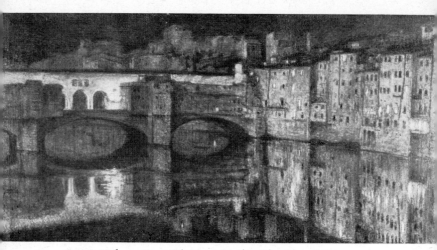

65 W. Holman Hunt *The Ponte Vecchio, Florence* c 1868
Watercolour 10″ × 21½″ Victoria and Albert Museum, London

Throughout his life he did however remain consistent to two principles. First, that art was not created for the initiated and sophisticated intellectual, but that it should be accessible and intelligible to a wider audience. Second, that art must be 'a handmaid in the cause of justice and truth'—in other words, that the artist must paint what he saw as he saw it in a truly Ruskinian sense. It is his adherence to these principles that allows us to admit his claim to have been a true Pre-Raphaelite all his life, and it is these principles which explain his great admiration for artists like Hogarth, Van Dyck and Tintoretto who seem superficially to have so little in common with his art or his intentions.

But though Hunt's knowledge of, and admiration for, Italian art was extensive, his own painting is notably free from stylistic borrowings or adaptations of any kind. Only in a few cases can a direct link be established, for example between Van Eyck's *Arnolfini Wedding* (National Gallery, London) and his *Lady of Shalott* (66). Hunt's originality therefore lay not only in his use of colour which was widely admired and imitated but also in both his power of composition, which in its honesty and its refusal to make the traditional compromises was to set wholly new standards, and in his choice of subject matter which was of greater importance to him than to most artists before or since.

Hunt is often dismissed as a gloomy and banal religious painter but he was, at least until the death of his first wife, an irreverent man of socialist leanings, and, as Rossetti wrote in 1853, ' ... jollier than ever with a laugh which answers one's own like a grotto full of echoes.' It was indeed in this period that he painted

66 W. Holman Hunt *The Lady of Shalott* 1857
Engraving $3\frac{5}{8}'' \times 3\frac{1}{8}''$
This illustration to the Moxon edition of Tennyson was based on a design originally sketched in 1850. A large version in oils, now in the Wadsworth Atheneum, Hartford, Conn., was painted 1887–1905, and a smaller version, now in the City Art Gallery, Manchester, concurrently.

67 W. Holman Hunt *The Festival of St Swithin* (*The Dovecote*) 1866–75
28¾" × 35⅞" Ashmolean Museum, Oxford

the majority of his most serious pictures, but *The Hireling Shepherd* (71), *The Awakening Conscience*, and even *The Light of the World* (62) are more than just moralistic tracts. Each of them is certainly imbued with meaning—the first an allegory of 'the muddle-headed pastor' diverted by worldly considerations from the proper care of his flock, the second an horrific representation of a fallen woman's remorse, the third an allegory of man's unwillingness to admit Christ and His teaching to his mind and life—but in each the purely *pictorial* elements, the relationship of the figures to their environment, and the powerful, vivid and poetic delineation of those environments, remain paramount. The popularity of the paintings with contemporary clergymen and missionary societies has unfortunately served for many years

to vitiate these pictorial qualities, but as fewer people remember *The Hireling Shepherd* as a Sunday School Bible illustration, more can appreciate it as an eloquent and felicitous work of art. In spite, indeed, of his declared anxiety not to become just a *paysagiste*, Hunt's subtle and expressive rendering of landscape in this, and in paintings like *The Dovecote* (67) and *The Sphinx at Gizeh* (68) is one of the most impressive features of his art.

Three other interlinking themes are to be found in all his work. He was of all the Pre-Raphaelites the most 'literary' artist. He first introduced Millais and Rossetti to Keats and it is said that he knew all the works of Tennyson by heart, while many of his paintings are clearly attempts to render pictorially the quality

68 W. Holman Hunt *The Sphinx, Gizeh, looking towards the Pyramids of Sakhara* 1854
Watercolour 10″ × 14″ Harris Museum and Art Gallery, Preston

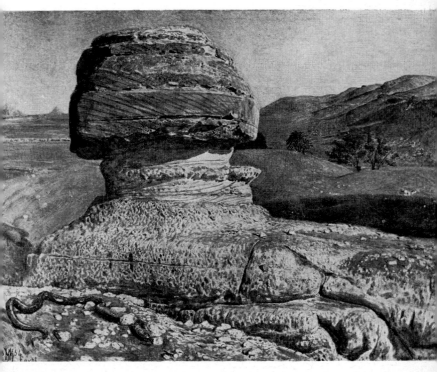

70 W. Holman Hunt, detail from *The Triumph of the Innocents* 1876–87
62″ × 97½″ Walker Art Gallery, Liverpool

69 W. Holman Hunt *Isabella and the Pot of Basil* 1867
72⅜″ × 44½″ Laing Art Gallery, Newcastle upon Tyne
Begun as a portrait of Hunt's first wife, but completed after her death.

which he so much admired in Thackerary of 'interpreting into contemporary and personal language the general moralising of others'. Throughout his life he painted major pictures on literary themes from the *Eve of St Agnes* (3) in 1848, *Isabella and the Pot of Basil* (69) in 1867, to the *Lady of Shalott* (66) first conceived as an engraving in 1850, and finally painted after 1887, and his imaginative and sensitive illustrations of these poems cannot be paralleled in the work of any other artist. Hunt's work indeed is more romantic than is often allowed. Not only in his subject matter, but in his treatment of it. The tender expressiveness of *Claudio and Isabella* is matched by the passion of *The Lady of Shalott*, and by the macabre figure of Isabella watering with her tears the pot in which the head of Lorenzo is buried. A sense of the macabre and the grotesque is not infrequent in Hunt's work. The reincarnated 'innocents' accompanying the Holy Family as a ghostly escort on the flight into Egypt (70), the snake in the foreground of the *Sphinx at Gizeh*, the intriguing symbolism of the Death's-head Moth in *The Hireling Shepherd*, and the entire conception of *The Scapegoat* (72) are examples of this, and they notably contribute to the expressive force of the paintings.

Hunt visited the Middle East in 1854, and twice later in life, and though there is no doubt that his reasons for making the

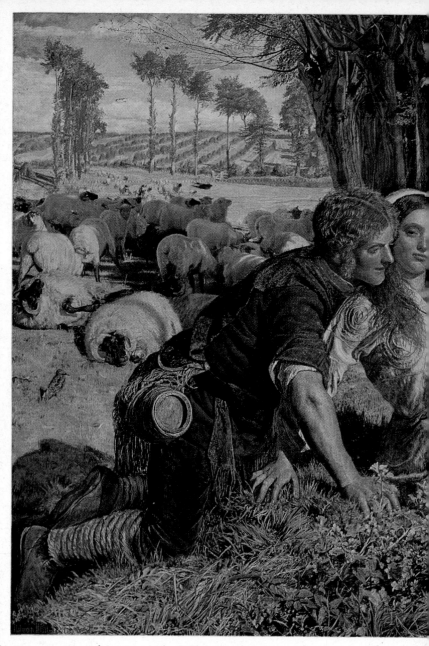

71 W. Holman Hunt *The Hireling Shepherd* 1851 $30\frac{1}{8}'' \times 43\frac{1}{8}''$

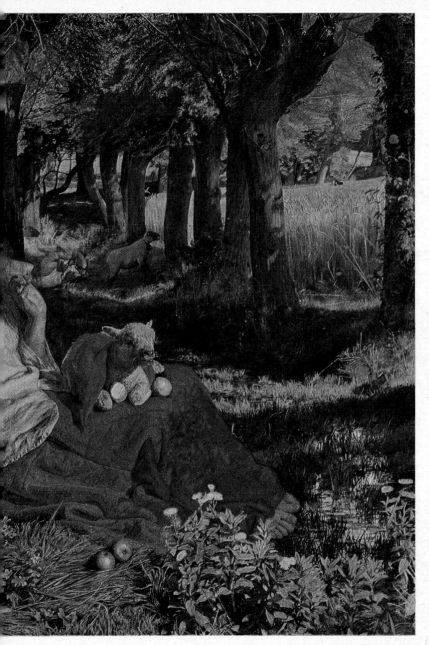

City Art Gallery, Manchester

first visit were by no means wholly religious, he painted on the shore of the Dead Sea in 1854 *The Scapegoat*, one of the most extraordinary and memorable of all religious pictures. It represents an attempt to produce a viable form of modern religious painting, for Hunt was convinced that the traditional symbols of religious art were as inappropriate to the mid-nineteenth century as were the traditional compositions and techniques. The subject, taken from the Talmud, represents the scapegoat traditionally driven from the Temple on the Day of Atonement to carry away the sins of the people, and though an image so bizarre and unfamiliar was not surprisingly greeted with general derision, it is as a painting a noble and interesting failure. As in *The Hireling Shepherd* the accurately and sensitively observed landscape forms a foil of a force equal to or even greater than that of the central subject, and the resultant image is almost surrealist in its impact.

It is said that Hunt could see the moons of Jupiter with his naked eye, and the sheer relentless penetration and clarity of his vision often gives his pictures a hectic intensity which it is sometimes hard for us to take seriously, but his best work is so sincerely expressive in its content and so eloquently true to the observed facts of nature in its form that though very different from it, it stands with Rossetti's as one of the finest and most individual achievements of nineteenth-century English art.

72 W. Holman Hunt *The Scapegoat* 1854
33¾″ × 54½″ Lady Lever Art Gallery, Port Sunlight

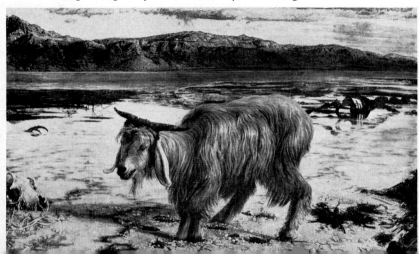

5 *John Everett Millais*

Millais was the youngest son of a well-to-do family from the Channel Islands; they never failed to encourage the artistic abilities which he displayed from a remarkably early age. When only nine he won a silver medal from the Royal Society of Arts, and in 1840, aged eleven, he entered the Royal Academy Schools. In the course of the next seven years his prodigious talents developed in an eclectic and ill-disciplined fashion. Any style, from the florid extravagance of Etty to the austere linearity of Flaxman, was within his capacity but he showed no indication of developing any personal or individual style at all.

Millais, in fact, had no great subtlety or originality of mind, nor any remarkable artistic or intellectual curiosity. 'Probably no artist in England,' wrote his son, 'ever read less on art than did Millais,' and it is not therefore suprising that he should so readily have fallen under the combined influence of Rossetti and Hunt in 1848. The imagination of the one and the determination of the other were to illuminate and justify a new world of creative expression which provided an adequate challenge to his abilities.

His early paintings indeed show a remarkable similarity in treatment and content to those of his companions. Compare, for example, *Christ in the House of his Parents* (28) and *The Druids* (30), and *The Return of the Dove* (37) and *Claudio and Isabella* (34). But notwithstanding the similarities, the derivation was certainly not direct and was probably a consequence of the regular discussion and exchange of ideas among the members of the Brotherhood at this stage. In *Mariana* (29) Millais achieved a wholly original fusion of Rossetti's romantic mediaevalising, and Hunt's meticulously expressed interest in natural objects observed in natural light. The means by which the glowing colours and intricate linear rhythms of the picture are used to impart the sense of langour and hopeless desolation explicit in Tennyson's poem are masterly—

> She only said 'My life is dreary—
> He cometh not' she said;
> She said, 'I am aweary, aweary—
> I would that I were dead'

In his drawings too the same influences are apparent. The spiky, awkwardly linear *Disentombment of Queen Matilda* (73) is clearly related to contemporary drawings by Rossetti (54), and perhaps to Madox Brown as well in its deliberate infelicities of style and its macabre historical allusion, while the similar and slightly earlier *Two Lovers by a Rosebush* (74) has affinities with Hunt's work for the *Germ* (27) for which indeed it was originally intended. Millais' graphic achievement is as distinguished as that

73 J.E.Millais *The Disentombment of Queen Matilda* 1849
 Pen and ink 9″ × 16⅞″ Tate Gallery, London

of Rossetti with which further parallels (e.g. shared Blakean motifs) can be traced; in the drawing done in 1856 to illustrate Coleridge's poem *Love* (75)—which is certainly one of his most tender and deeply expressive—the heavily worked over surface, the curvilinear and carefully modelled forms and the enclosed foreground composition through which is only glimpsed a spacious but subordinated background could almost be by Rossetti himself.

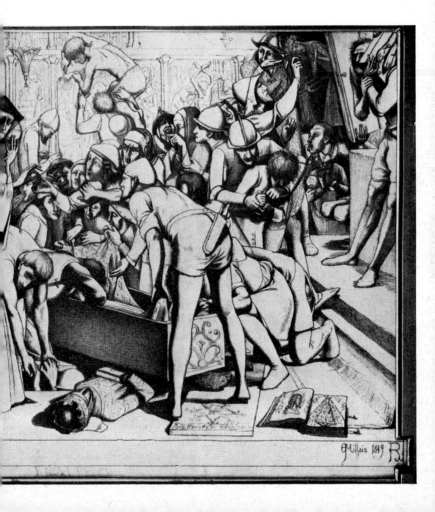

74 J.E.Millais *Two Lovers by a Rosebush* 1848
Pen and ink $10\frac{1}{8}'' \times 6\frac{1}{2}''$ City Museum and Art Gallery, Birmingham

75 J.E.Millais *Love* c 1856
Pen and wash 5″ × 3¾″ Victoria and Albert Museum, London

In 1853 Millais visited Scotland with Ruskin his friend and champion, and while there began work on the portrait (76) which exemplified in the handling of the background so many of Ruskin's ideas about art. The years 1853–5 were of exceptional mental and emotional turmoil for the two men, ending with Ruskin's divorce and his wife's marriage to Millais. The portrait, it is said, had to be completed in Millais' London house at the height of the crisis, with Ruskin posed at the top of the stairs while he was painted from the bottom, the two exchanging not a word.

Ruskin, however, was not an ungenerous man and his *Notes* on the Academy Exhibition of 1856 bestow lavish praise on Millais' paintings (78, 79, 80). If Millais' early work can be related to Hunt's in its objective honesty of expression and lambent colour, the usually less offensive, or at least less obtrusive, iconography has been modified further by 1856. In *Ophelia* of 1852 (77) the madness of the girl is subtly and effectively heightened by the hectic profusion of the flowers and weeds which frame her (a powerful contrast with the enormously complex and elaborate symbolism of Hunt's *Awakening Conscience*), and in the *Blind Girl* of 1856 (78) a similar device—the oncoming thunderstorm and the profusion of wayside flowers and insects—gives a poignant seriousness to the scene without overloading it with anecdotal significance.

It is, however, perhaps in *Autumn Leaves* (79) that Millais reached the peak of his achievement. Hunt recalled a remark of Millais' which may have been the genesis of the picture: 'Is there any sensation more delicious than that awakened by the odour of burning leaves? To me nothing brings back sweeter memories of the days that are gone; it is the incense offered by departing summer to the sky . . .' *Autumn Leaves* is, as Ruskin observed, his most poetical painting, and its delicate fusion of mystery and actuality sets it apart as one of the most evocatively haunting of all English paintings. It is not surprising that Ruskin should have compared it to Giorgione, for it contains something of the

76 J.E.Millais *John Ruskin* 1854
$31'' \times 26\frac{3}{4}''$ Coll. Mrs Patrick Gibson (Photo Royal Academy)

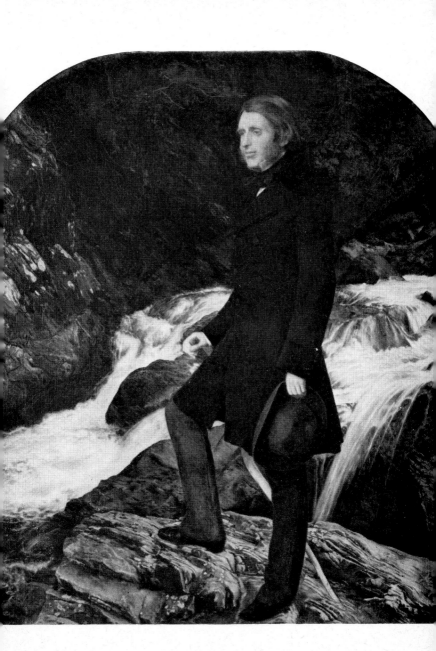

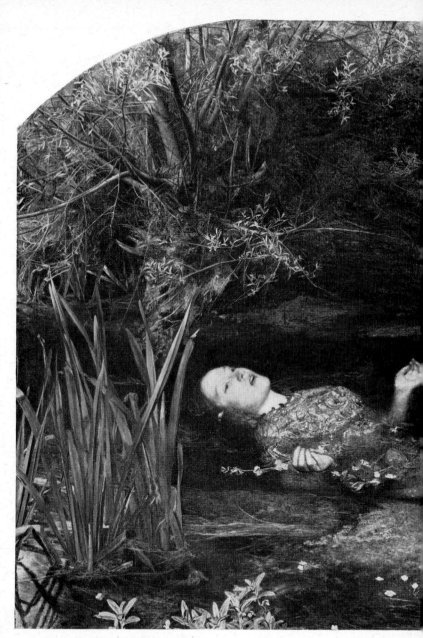

77 J.E.Millais *Ophelia* 1852
30″ × 40″ Tate Gallery, London

The model was Elizabeth Siddal, and this painting was said by
W.M.Rossetti to be the best likeness of her.

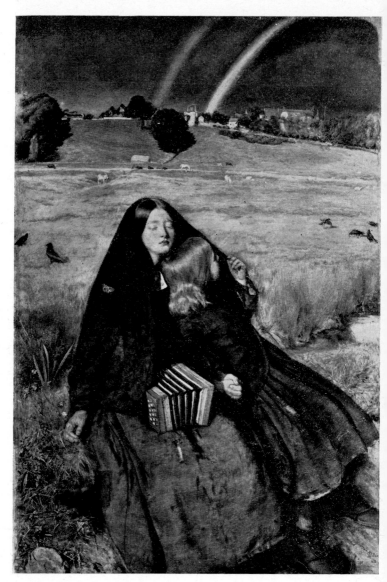

78 J.E.Millais *The Blind Girl* 1856
32″ × 24½″ City Museum and Art Gallery, Birmingham

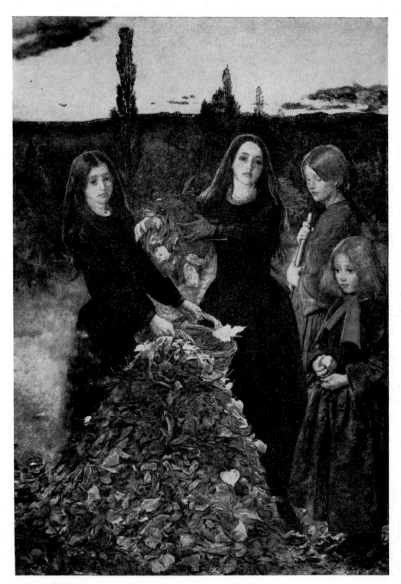

79 J.E.Millais *Autumn Leaves* 1856
41″ × 29⅛″ City Art Gallery, Manchester

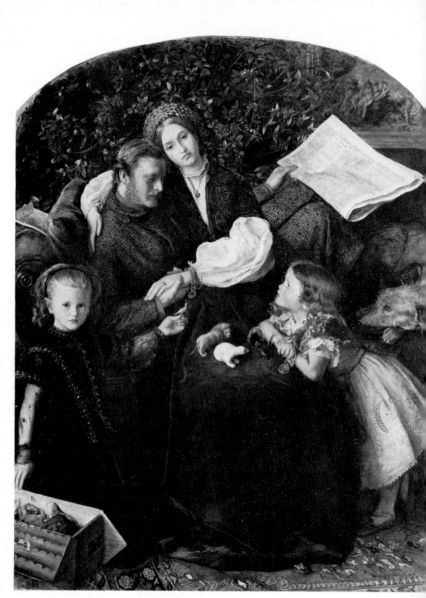

80 J.E.Millais *Peace Concluded* 1856
46″ × 36″ Minneapolis Institute of Fine Arts

seductive mystery of his art. But Ruskin's enthusiastic praise, even at the time a little fulsome ('Titian himself could hardly head him now,' he commented of *Peace Concluded* (80)) was not to be justified by Millais' future achievement. At the Royal Academy in the following year he exhibited *Sir Isumbras at the Ford* (81) which Ruskin castigated as 'not merely Fall—it is Catastrophe', and later generations have seen no reason to differ from his judgement. The technique was looser than hitherto, and the subject had the straightforward sentimental appeal which was to characterise so much of Millais' later work. Chronologically this change in style is so close to his marriage that it is hard to believe that there is no actual connection. Millais now was working 'for a wife and children' and could no longer afford to spend a day painting an area 'no larger than a five shilling piece'.

81 J.E.Millais *A Dream of the Past: Sir Isumbras at the Ford* 1857
49″ × 67″ Lady Lever Art Gallery, Port Sunlight
Exhibited with lines from a pastiche of an old romance by Millais' friend Tom Taylor.

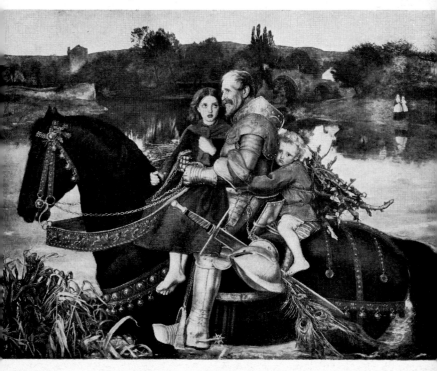

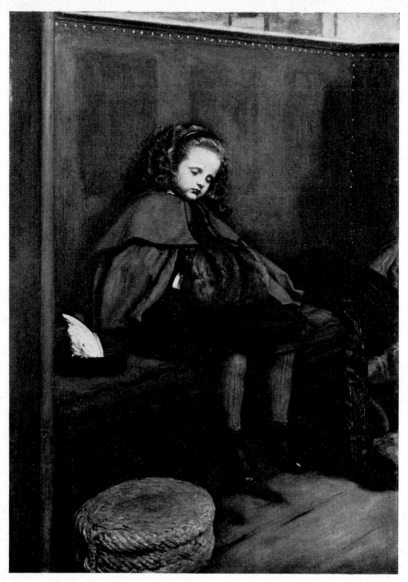

82 J.E.Millais *My Second Sermon* 1864
36″ × 28″ Guildhall Art Gallery, London
(Photo R. B. Fleming and Co.)

In changing from his astringent and personal early style he enormously enhanced his popularity with the public and enlarged his circle of patrons. The prices paid for his work rose quite dramatically and by 1864 he was not above exhibiting a picture —*My Second Sermon* (82) whose only point was to make a joke out of one of his pictures exhibited the previous year—*My First Sermon*. The girl was then awake. Both pictures were praised by the Archbishop of Canterbury and enjoyed an enormous popular success.

In 1886, seeing his work collected at an exhibition, Millais confessed to a friend that he too felt that he had in his maturity failed 'to fulfil the full forecast of my youth'. But he was by then the first British artist to have been made a baronet, and was earning over £30,000 a year from his work. Though most of his later paintings betray his laziness of mind and paucity of inspiration, his technical facility and sensitivity of observation give his later landscapes, portraits and even some of his 'subject pieces' (83) a dignity and power which contrasts strongly with the florid theatricality of those of most of his rivals and of his own inferior productions.

83 J.E.Millais *The Ruling Passion* (*The Ornithologist*) 1885
 $63\frac{1}{4}'' \times 85''$ Museum and Art Gallery, Glasgow

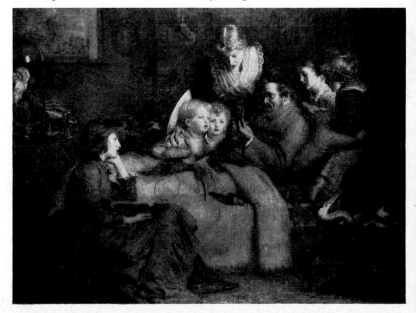

6 Associates

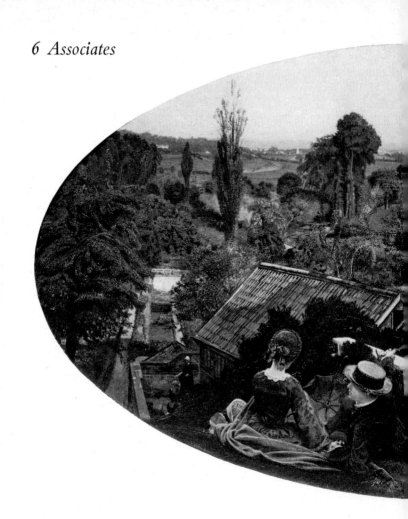

By 1854 the *Pre-Raphaelite Brotherhood* can be said in a very real sense to have lapsed, but its two conjoint manifestations, the *Pre-Raphaelite Movement*, and the school of *Pre-Raphaelitism* which derived from it can be observed through almost the entire artistic and cultural world of the second half of the nineteenth century. Indeed, transformed and modified by the Aesthetic and

84 F. Madox Brown *An English Autumn Afternoon* 1852–4
$28\frac{1}{4}'' \times 53''$ City Museum and Art Gallery, Birmingham

Arts and Crafts Movements—or ossified in the minds of con-
servative painters and patrons—it continued well into the second
quarter of the twentieth century. *Pre-Raphaelitism* as a state of
mind, an attitude of observing the world, was to become a
largely literary phenomenon and its influence can be traced
through the early work of Swinburne to Walter Pater and the

aesthetic poets of the nineties, Ernest Dowson and Lionel Johnson. Perhaps the last great literary figure to draw major inspiration from the same source was W.B.Yeats who once described himself, not altogether misleadingly, as 'in all things Pre-Raphaelite'.

The *Pre-Raphaelite Movement* can be said to include all those artists whose work was consciously influenced by the paintings and ideals of the Brotherhood, without themselves being members, and it was inaugurated in 1850 by Collins' *Berengaria* (85).

Far and away the most important and complex of the Brotherhood's associates was Ford Madox Brown. His seminal influence has already been discussed, but the work of his disciples was to have an equally salutary effect on his own painting. His early interest in naturally sunlit subjects is evident in the Byronic *Manfred* of 1841 (86), but this relatively crude naturalism had by 1852 developed into the infinite subtlety and delicacy of observation of *An English Autumn Afternoon* (84) and *The Last of England* (87). The light is subdued; in the latter, inspired by the emigration

85 Charles Alston Collins *Berengaria Recognising the Girdle of Richard I Offered for Sale in Rome (The Pedlar)* 1850
38″ × 49½″ City Art Gallery, Manchester

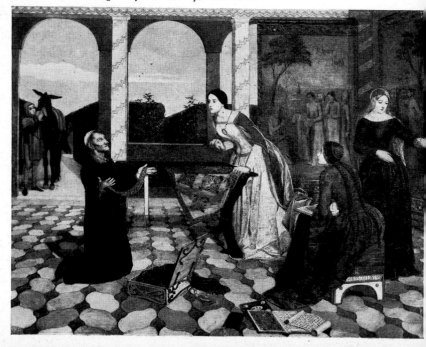

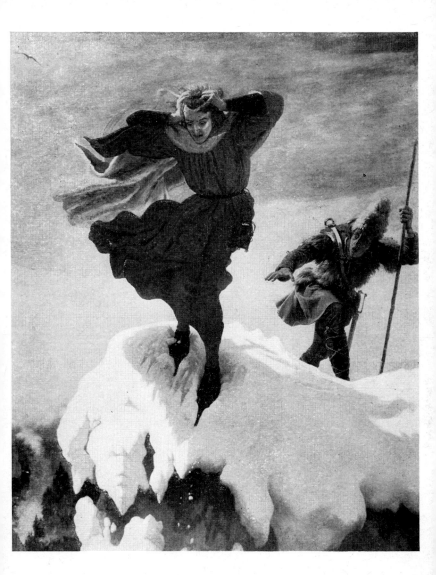

86 F. Madox Brown *Manfred on the Jungfrau* 1841 retouched 1861
$55\frac{1}{2}'' \times 45\frac{1}{2}''$ City Art Gallery, Manchester
The subject is from Byron's *Manfred*, Act I, scene 3.

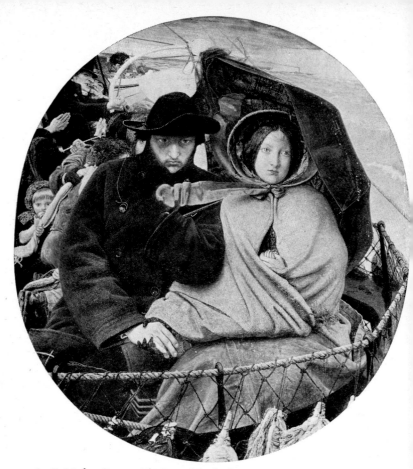

87 F. Madox Brown *The Last of England* 1852–5
32½″ × 29½″ City Museum and Art Gallery, Birmingham

of Woolner and his wife to Australia, the sky is overcast, while
in the former, representing the view from the artist's lodgings in
Hampstead at 3 p.m. on a late October day 'the grey mist of
autumn' is rising, 'the shadows already lie long' and 'the sun's
rays (coming from behind us) are preternaturally glowing'. In
both, the light is used to envelop and articulate the scene with
extraordinary skill, and in *An English Autumn Afternoon* in
particular, it becomes a diaphanous presence, defining each object
with precision, and relating objects both to each other and to the

spatial unity of the picture which it emphasises with a deftness and sensitivity rare in contemporary art.

Less successful, perhaps, and certainly a less agreeable visual experience, was his idiosyncratically titled *Pretty Baa Lambs* (88) of approximately the same date. (Most of Brown's pictures were painted over a long period of years, in this case eight, with constant retouchings and revisions being made.) It was in one respect an important picture, however, for it was, wrote the artist 'painted almost entirely in sunlight. This, twice,' he continued, 'gave me a fever while painting . . . The lambs and the sheep used to be brought every morning from Clapham Common in a truck; one of them ate up all the flowers one morning in the garden and they used to behave very ill.' Its only

88 F. Madox Brown *The Pretty Baa Lambs* 1851–9
24″ × 30″ City Museum and Art Gallery, Birmingham

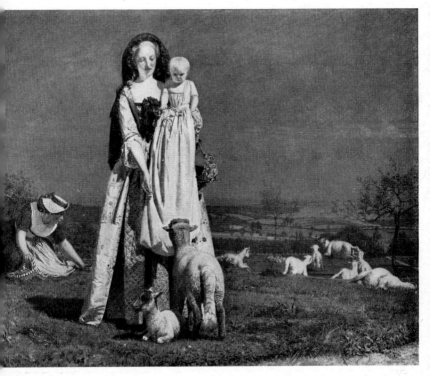

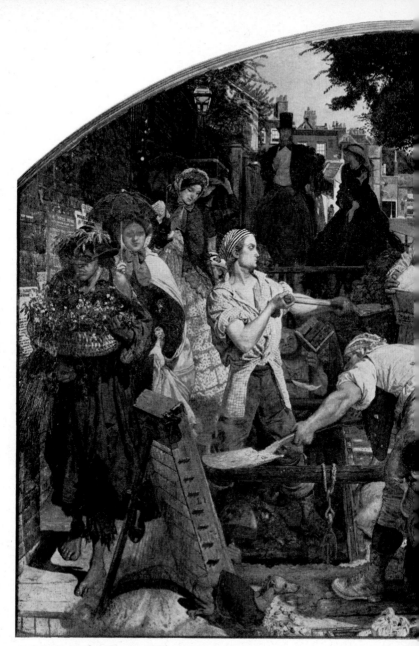

89 F. Madox Brown *Work* 1852–65
54½″ × 77⅛″ City Art Gallery, Manchester

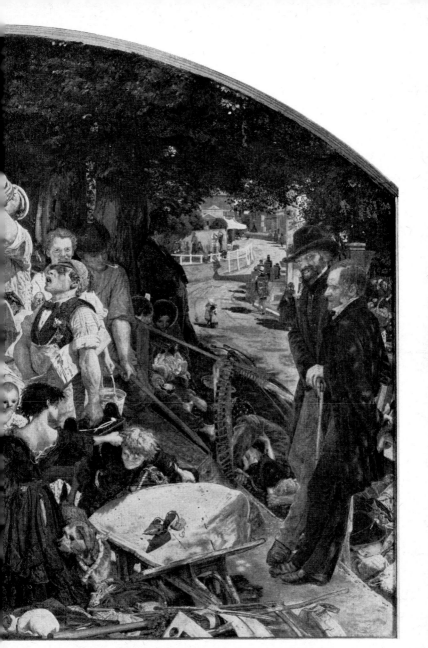

The background, painted in Heath Street, Hampstead, is still recognisable.

meaning, he said, was to render the effect of sunlight as well as his powers would allow, and this is where the importance of the picture lies, for its 'truth to nature' is not softened by any narrative sentiment, and though R.A.M.Stevenson, the art critic, exaggerated when he claimed that the whole history of modern art began with it, that 'Corot, Manet, the Marises, all the Fontainebleau school, all the Impressionists, never did anything but imitate that picture' it is in its stark brilliance a startlingly original work.

In *Work* (89), begun in 1852 but not finished till 1865, Brown produced a pictorial representation of Carlylean social philosophy. The painting, of a considerable compositional and anecdotal complexity, symbolises work in all its forms—Thomas Carlyle himself having sat with the Rev. F.D.Maurice (a leader of the Christian Socialist Movement) for the 'brainworkers' on the right-hand side of the canvas. The rest is taken up with assorted and contrasted examples of 'town pluck and energy', 'country thews and sinews', the unemployed, the orphaned, the idle poor, the idle rich and the proselytes. Each is provided with attributes almost in the manner of saints in a Renaissance altarpiece, though in this case an elaborate guide to the frequently novel symbols employed was published by the artist. Of all Pre-Raphaelite pictures this is perhaps the one of which it can most justly be said that the whole is less than the sum of all the parts. It contains a large number of endlessly inventive and original details, but the totality, though again suffused with brilliantly realised summer sunlight, does not cohere into a unity. There are too many divergent and divisive visual accents.

As a social document, however, *Work* is of considerable interest, and it has always been regarded as a central Pre-Raphaelite painting by those who see the movement as one of radical social and political intent. It would, however, be wrong to exaggerate this aspect of the revolt, for the radicalism of *Work* lies in its subject, and in the nature of the representation of it, and hardly at all in the use to which the subject is put. It is not a denunciation of the exploitation of labour inherent in a capitalist state, still less is it a declaration of the dignity of labour. It is simply a representation of it. Much more impressive and moving, and explicitly socialist in motivation, was Henry Wallis' *Stonebreaker* of 1858 (32). For the stonebreaker has died at his work, and while the

magically luminous twilight landscape in which he lies but which he cannot apprehend provides a visual foil to this human tragedy, a quotation from Carlyle's *Sartor Resartus* provides the intellectual setting: 'Hardly entreated Brother! For us was thy back so bent for us were thy straight limbs and fingers so deformed: thou wert our Conscript . . . For in thee too lay a God-created Form, but it was not to be unfolded; encrusted must it stand with the thick adhesions and defacements of labour; and thy body, like thy soul, was not to know freedom.' Wallis (1830–1916) is a shadowy figure of whom little is known. His only other surviving painting of any importance, *The Death of Chatterton* (90), is also a hauntingly memorable portrayal of the corpse of a man denied fulfilment by society.

90 Henry Wallis *The Death of Chatterton* 1856
$24\frac{1}{2}'' \times 36\frac{3}{4}''$ Tate Gallery, London

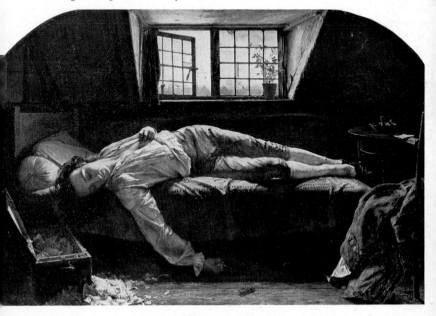

91 William Bell Scott *Iron and Coal* c 1860
74″ × 74″ National Trust, Wallington Hall, Northumberland
The high-level bridge over the Tyne at Newcastle can be seen in the
background.

The representation of contemporary labour, in this case some-
what idealised, is again to be seen in *Iron and Coal* (91) by the
Newcastle painter, poet and one-time friend of Rossetti,
William Bell Scott (1811–90), and it was a theme to which
Madox Brown returned at the end of his life in a whole series of
paintings which he made for the Corporation of Manchester.
In the Great Hall of Waterhouse's recently completed

Town Hall he executed a cycle of twelve murals (1878–93) illustrating scenes from the history of the town (92) in an unmistakably Pre-Raphaelite style which nevertheless forshadowed the work of Stanley Spencer and other English artists of the 1920s in a quite remarkable way, and which are among his finest and most undervalued achievements; while for the Jubilee Exhibition of 1887 he painted a series of vast allegorical canvases, each representing a different Lancashire trade or industry (City Art Gallery, Manchester).

92 F. Madox Brown, detail from *The Establishment of the Flemish Weavers in Manchester AD 1363* 1882
Fresco: Town Hall, Manchester

93 William Braithwaite Martineau *The Poor Actress' Christmas Dinner*
c 1855
$14\frac{1}{2}'' \times 19''$ Ashmolean Museum, Oxford

Social realism was, however, but one of the Pre-Raphaelite preoccupations which influenced the admirers of the Brotherhood. Each of the Brethren attracted followers to themselves personally, and as the next chapter will show, Rossetti's disciples succeeded to some extent in a spiritual, emotional and artistic sense in bringing the whole movement back to life. Two of Hunt's pupils and admirers, Edward Lear (1812–88) and Robert Braithwaite Martineau (1826–69) were only marginally influenced by the deeper motives of the Brotherhood. Lear remained an amateur landscape watercolourist and in spite of his often expressed desire to paint large and highly finished eastern scenes in oils, few were ever completed and fewer still survive today. Martineau became primarily a genre painter of a conventional mid-Victorian kind, but a few of his paintings done under Hunt's tutelage like the unfinished *Poor Actress' Christmas Dinner* (93) do achieve something of the pathos and vigour to which his art aspired. Thomas Seddon (1821–56), a member of the circle from

as early as 1849—who was said to have remarked that three months was insufficient time to draw properly the branch of a tree—was, however, one of the first of that group of artists (to become more numerous as the century advanced) on whom Pre-Raphaelite principles exerted an influence which can justly be described as malign. He visited the East with Hunt in 1854, and his major painting, *Jerusalem and the Valley of Jehosophat* (94), was done there. It only took him five months to finish, but as Madox Brown wrote, it is 'cruelly P.R.B.'d . . . the high finish is too obtrusive . . . it presents qualities of drawing and truthfulness seldom surpassed; but no beauty, nothing to make the bosom tingle . . .'.

94 Thomas Seddon *Jerusalem and the Valley of Jehosophat* 1854
$26\frac{1}{2}'' \times 32\frac{3}{4}''$ Tate Gallery, London

The airless aridity of Seddon's work is not altogether absent from some of the similarly topographic landscape paintings of John Brett (1831–1902) and J.W.Inchbold (1830–88). Brett's *Val d'Aosta* (95) is remarkable both for its unique fidelity of representation and as one of the very few individual pictures which Ruskin directly influenced. In the end he was disappointed by it —'I never saw the mirror so held up to Nature' he commented, adding sourly, 'but it is Mirror's work, not Man's'. Brett, however, had proved a less amenable student than Inchbold whose *White Doe of Rylstone* (97) so excited Ruskin that he spent three summers with Inchbold painting in Switzerland, before abandoning him as a pupil for Brett, who, he wrote to his father, 'is much tougher and stronger than Inchbold, and takes more hammering; but I think he looks more miserable every day, and have good hope of making him completely wretched in a day or two more'. As with so many artists inspired by the vision of the early Pre-Raphaelites, the quality of Brett's and Inchbold's work fell during the 1860s as a mechanical and routinely efficient delineation of subject succeeded the fresh and glowing intensity of their early paintings.

Apart from his brother William, a painstaking and meticulous watercolourist, Millais' most important follower was the gentle and self-effacing Arthur Hughes (1832–1915). Remarkably little is known of his life, but his first introduction to Pre-Raphaelite ideas was as one of the few readers of the original *Germ* in 1850. In 1852 he exhibited *Ophelia* (98)—the same year as Millais' *Ophelia* though in no way related to it. The use of the background to heighten and intensify the emotional state of the participants was a Pre-Raphaelite characteristic which Hughes adopted and developed in all his important work (substantially confined to the following decade). In *The Long Engagement* (99) the rank and oppressive undergrowth vividly evokes the tragic, self-consuming and self-destroying nature of the unconsummated relationship; in *Home from Sea* (96) the pathos of the young sailor with his sister at his mother's graveside is counterpointed by the evidence all around of spring. This contrast between death

95 John Brett *Val d'Aosta* 1858
$34\frac{1}{2}'' \times 26\frac{3}{4}''$ Coll. Sir William Cooper, Bt. (Photo Royal Academy)

96 Arthur Hughes *Home from Sea* (*A Mother's Grave*) 1857
20″ × 25¾″ Ashmolean Museum, Oxford

Painted in the old churchyard at Chingford, Essex; the figure of the sister was added in 1863.

97 John William Inchbold *The White Doe of Rylstone (At Bolton)* 1855
27" × 20" City Art Gallery, Leeds
Painted at Bolton Abbey to illustrate the first canto of Wordsworth's
White Doe of Rylstone.

98 Arthur Hughes *Ophelia* 1852
27" × 48¾" City Art Gallery, Manchester

and rebirth was a favourite of Victorian artists, and there are other examples in Pre-Raphaelite canon, e.g. Henry Bowler's *The Doubt: 'Can These Dry Bones Live?'* (101), but Hughes, more than any other major figure in the movement, was influenced by sentimental contemporary attitudes towards love and death. This was to become more apparent in his later work like the touching *Geraint and Enid* (100), but it is incipient in *Home from Sea* where only the purity of colour, and the starkness and emotional restraint of the treatment relieve the sentimental potential of the scene. Hughes, like Millais was a fine draughtsman and much of his best work, particularly after 1860 is in the form of book illustrations, and drawings (102) notable for their sensitivity and linear precision. They are often laden with emotional overtones, but the best avoid the pitfalls of banality and vapidity into which so many contemporaries stumbled.

99 Arthur Hughes *The Long Engagement* 1859
$41\frac{1}{2}'' \times 20\frac{1}{2}''$ City Museum and Art Gallery, Birmingham

101 Henry Alexander Bowler *The Doubt: 'Can These Dry Bones Live?'*
1856
24″ × 20″ Tate Gallery, London
The butterfly on the skull and the chestnut which has put forth a
shoot on the tombstone inscribed 'Resurgam' indicate that the answer
is yes.

100 Arthur Hughes *Geraint and Enid* c 1860
9″ × 14″ Coll. Lady Anne Tennant (Photo Rodney Todd White)
Frame inscribed 'The brave Geraint, a knight of Arthur's Court, had
wedded Enid, Yniol's only child, and loved her, as he loved the light
of heaven'.

One of Hughes' friends, and also a friend of Rossetti, Woolner and others of the group, was Alexander Munro (1825–71) the sculptor. Sculptural Pre-Raphaelitism is hard to define, but in Munro's few surviving imaginative works (103) there is a quality of representational integrity which links them with the paintings of his friends, and in the case of *Paolo and Francesca* it has recently been shown that the group is probably derived from a Rossetti drawing of the same subject (104). A savage attack on his sculptures in the 1862 Exhibition—'such vague writhing forms have not even a good doll's likeness to human children'—by F.T.Palgrave (a friend of Woolner's anxious to denigrate any rival) discouraged Munro, however, and, already an ill man, he confined himself in the last decade of his life mainly to the production of portrait busts and medallions.

William Lindsay Windus (1823–1907) was another follower of the group whose sensitivity was such that a critical notice, in this case from the notoriously capricious Ruskin, followed shortly afterwards by the death of his wife, caused him to destroy most of his work and then virtually to stop painting altogether. A native of Liverpool, Windus was the most important of the group of local artists, mostly landscape painters, who were influenced by the success of Pre-Raphaelite paintings at the annual Liverpool exhibitions, where they had won the annual prize five times between 1851 and 1858, the first time on a motion proposed by Windus himself. He exhibited his first, and finest, Pre-Raphaelite painting in 1856—*Burd Helen* (105); the story, from an old Scottish ballad, tells of a girl who ran all day beside the horse of her faithless lover and on reaching the Clyde decided to swim across rather than lose him. It was very greatly admired by Rossetti who thought it 'the finest thing of all' in the Academy that year, and by Ruskin who considered it 'the second picture of the year'. In 1859 the more sensational *Too Late* (106) prompted the criticism of Ruskin, who not unjustly found the picture morbid, and the

102 Arthur Hughes *Two Lovers by a Sundial* c 1870
Pen and ink $5\frac{1}{2}'' \times 4\frac{1}{2}''$ Ashmolean Museum, Oxford
Engraved and published in *Good Words* 1871.

103 Alexander Munro *Paolo and Francesca* 1852
Marble $26\frac{1}{2}''$ high City Museum and Art Gallery, Birmingham
The subject is taken from *The Inferno*, Canto V.

104 D.G.Rossetti, detail from *Paolo and Francesca* 1855
Watercolour. Tate Gallery, London
This was painted from a drawing of c 1850 which had probably
served as Munro's source.

104

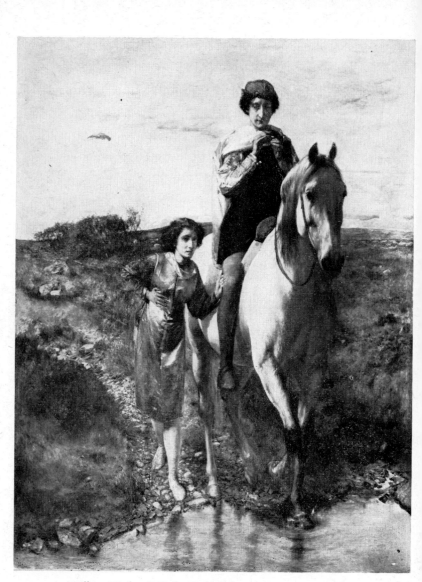

105 William Lindsay Windus *Burd Helen* 1856
$33\frac{1}{4}'' \times 26\frac{1}{4}''$ Walker Art Gallery, Liverpool

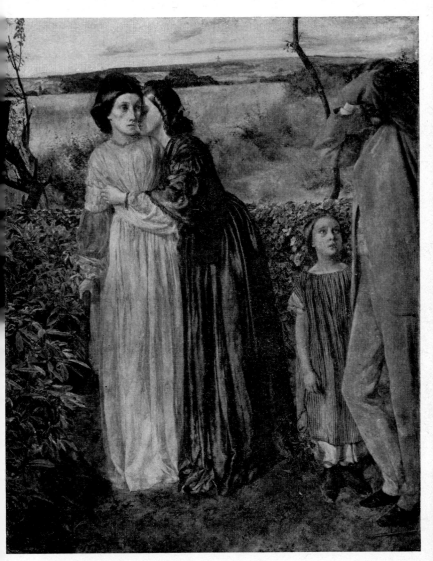

106 W.L.Windus *Too Late* 1858
$37\frac{1}{2}'' \times 30''$ Tate Gallery, London
The faithless lover has returned, only to find his beloved dying of
tuberculosis.

neurotic artist thereafter virtually ceased to paint, but *The Hunted Outlaw* (108), one of the few examples of his later work to survive, displays the same careful attention to detail, the same muted palette, the same urgent intensity of subject matter, and

107 G.F.Watts *Mrs Nassau Senior* 1858
68″ × 40″ Private Collection (Photo Arts Council)
Exhibited under the pseudonym F.W.George

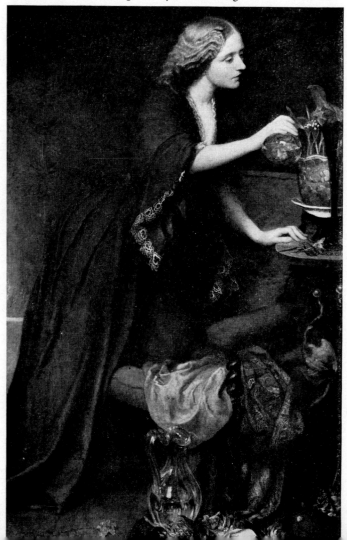

108 W.L. Windus *The Hunted Outlaw* 1861
13″ × 12½″ City Art Gallery, Manchester

the same striking and original compositional arrangement as his earlier paintings.

Ford Madox Brown was not the only established artist who was moved to modify his style as the Pre-Raphaelite movement gained the approval of the gallery-going public in the early 1850s. Even such unlikely artists as Daniel Maclise and J.B. Philip were briefly claimed as converts to the movement, but usually the conversion consisted only of devoting a little more attention than hitherto to foreground detail or local colour in one or two current paintings. Four artists, however, all of real and already established stature did produce a number of what were in effect Pre-Raphaelite paintings and drawings which differed substantially from their

current work. Frederick Leighton (1830–96) and G.F.Watts (1817–1904) both produced work as a deliberate, if lighthearted, challenge to the Brotherhood—the former a series of drawings of trees and flowers, and the latter a portrait which he exhibited at the Academy under a false name (107). William Dyce (1806–64) and Augustus Egg (1816–63) were both Associate Academicians by 1848 and were among the few members of that body who were from the outset sympathetic. Their influence however, stylistic and social, was hardly less than their subsequent artistic indebtedness to the Brotherhood. Dyce's imitation of the early Italians (15) was transformed, perhaps as a consequence of Ruskin's criticism, to the meticulous observation of natural objects in natural light (109), and though in many of his later pictures the figures are subordinated to the landscape, there is often a brooding and individual intensity about the latter which links the paintings to those of Rossetti and Hunt. Egg, Hunt's friend and patron, was a typical romantic genre painter whose work again acquired a new and derivative gravity in the last years of his life, culminating in his moralistic tryptych *Past and Present* (Tate Gallery) on the theme of marital infidelity, which is related to the work of Hunt not only in subject matter but also in its exploration of the possibilities of painting naturalistic night scenes illuminated only by the moon.

James Smetham (1821–89), a versatile but unsuccessful artist, provides an independent link with the world of Blake (of whom he published one of the first studies), and more surprisingly with that of Samuel Palmer, to whose early work many of his paintings are, as Rossetti observed, remarkably akin. A friend of Rossetti in the late fifties and sixties, his *Eve of St Agnes* (110) with its tentative technique, its Keatsian subject matter and its spatial compression, is unmistakable witness to his influence though still infused by a highly independent artistic vision.

109 William Dyce *Titian's First Essay in Colour* 1857
36″ × 26½″ Art Gallery and Museum, Aberdeen

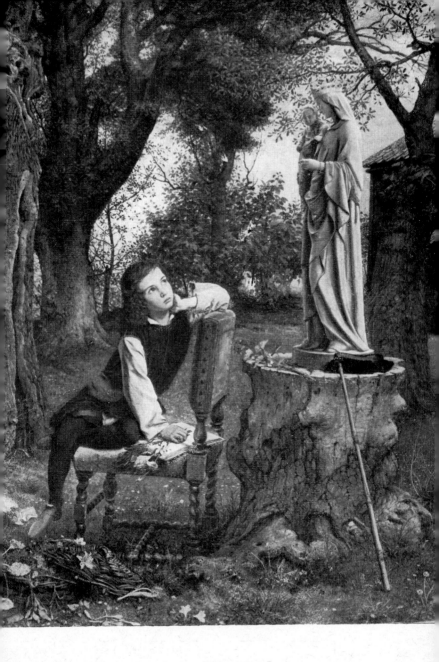

Frederick Sandys (1829–1904) was another of Rossetti's friends who was to fall entirely under his spell. His relationship with the Brethren began with a caricature of them published in 1857, and certainly his greatest talent was for engraved book illustration, but within a few years he was producing minutely observed, mystically erotic paintings on generalised and highly imaginative mediaeval and literary themes (111), very much in the style of his mentor.

111 Anthony Frederick Augustus Sandys *Morgan–Le–Fay* 1864
$24\frac{3}{4}'' \times 17\frac{1}{2}''$ City Museum and Art Gallery, Birmingham
Morgan-le-Fay was King Arthur's half-sister, and hated him for his goodness. She is weaving an enchanted mantle designed to consume his body by fire.

110 James Smetham *Eve of St Agnes* 1858
Pen, ink and wash $3\frac{1}{4}'' \times 4''$ Tate Gallery, London

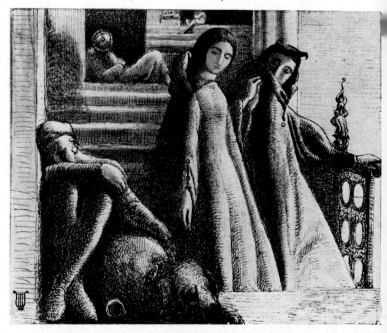

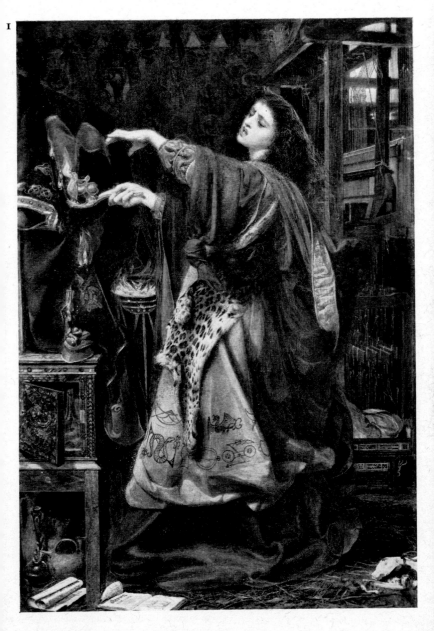

The list of artists affected at some time or other by hard-edge Pre-Raphaelitism is capable of almost infinite extension both numerically and even geographically. William Shakespeare Burton (1824–1916) painted little because of 'ill-health and private sorrows' after his *Wounded Cavalier* of 1856 (112), but that is certainly typical of the sort of picture which was by then covering the Academy's walls, for 'the battle', wrote Ruskin the same year, 'is completely and confessedly won'. The Pre-Raphaelites were triumphant and 'comparatively few pictures' remained of the old school.

Geographically speaking, two 'provincial' artists merit brief consideration. Noel Paton (1821–1901)—later a knight and

112 William Shakespeare Burton *A Wounded Cavalier* 1856
35″ × 41″ Guildhall Art Gallery, London
(Photo R. B. Fleming and Co.)

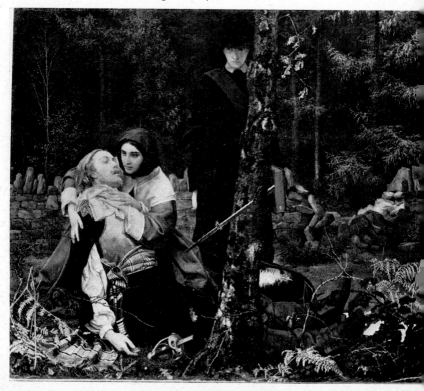

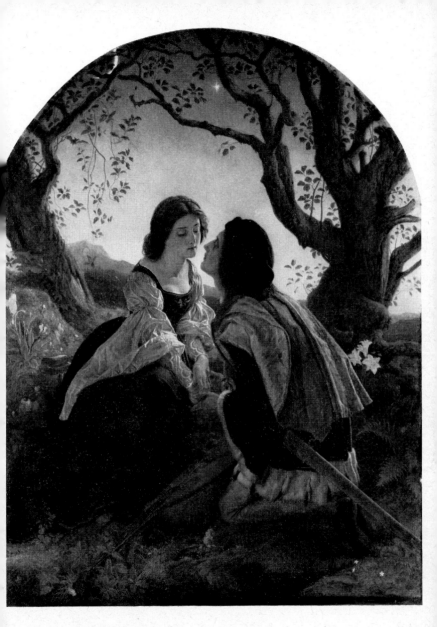

113 Noel Paton *Hesperus* 1857
36″ × 27″ Museum and Art Gallery, Glasgow

'Queen's Limner for Scotland' had been a friend of Millais' since the early forties and an associate and admirer of the Brotherhood from its inception. The quite extraordinary elaboration of his pictures, their sometimes mawkish iconography, their very professionalism of technique, and not least their enormous popular success at the end of the last century have contributed to their present neglect (113). Working in Scotland most of his life and therefore out of touch with new ideas, Paton's style did not alter greatly over the years; the Pre-Raphaelite influence was permanent and for all their lush facility, his paintings have sometimes a dramatic and urgent intensity which sets them apart (114) from those of less talented followers.

The other peripheral manifestation of Pre-Raphaelitism worthy of note was in America. Several attempts were made to transplant the movement, encouraged by the writings of Ruskin, the enthusiasm of American collectors, the loan exhibition of British Art in New York in 1857 which inevitably included many Pre-Raphaelite paintings, and the prolonged advocacy of the movement by the American artist, W.J.Stillman. His wife, Marie Spartali, was a model of Rossetti, a pupil of Madox Brown and perhaps the most important American Pre-Raphaelite painter (115). Though not without influence on contemporary artists, however, American Pre-Raphaelitism cannot be said to have been of much lasting importance. The movement itself became in the American context a substantially literary and philosophical affair, and its two journals *The Crayon*, edited by Stillman, and *The New Path* published by the Society for the Advancement of Truth in Art, had both ceased publication by 1865. The most important legacy of the American interest was perhaps the early formation of important collections of Pre-Raphaelite art by Samuel Bancroft at Wilmington, Delaware, and by Charles Eliot Norton at Harvard, but it also served to consolidate the American acceptance of Ruskin as an authoritative critic and to make the later productions of Morris and Burne-Jones more readily appreciated in the U.S.A. A significant proportion of their work was indeed done for American clients, but the peculiar blend of realism and romanticism which is apparent in much mid-century American painting was an indigenous development owing little or nothing to specifically English precedents.

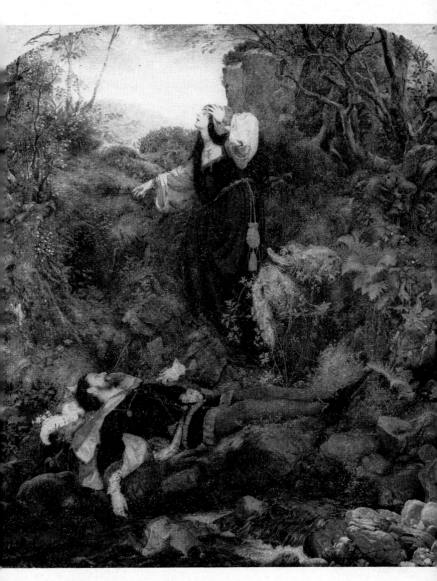

114 Noel Paton *The Bluidie Tryst* 1855
$28\frac{3}{4}'' \times 25\frac{5}{8}''$ Museum and Art Gallery, Glasgow

115 Marie Spartali Stillman *The Convent Lily* 1891
$17\frac{1}{2}'' \times 13\frac{3}{4}''$ Ashmolean Museum, Oxford

7 Successors

None of the artists discussed in the last section did any more than interpret in their own terms, with greater or lesser degrees of fidelity and success, the pictorial formulae evolved by the members of the original Brotherhood.

In this they can be compared to William Morris (1834–96) and Edward Burne-Jones (1833–98), who, while students at Oxford together in 1854, first discovered the writings of Ruskin and the paintings of the Pre-Raphaelites. They succeeded in deriving and developing from the now fragmented movement a new, coherent, and influential inspiration which can perhaps retrospectively be dignified by the term 'second generation Pre-Raphaelitism'. Not because their aims and ideals were closely linked to those of the original Brotherhood, but because the forms, literary and artistic, in which they expressed themselves were similar; owing to their close friendship with Ruskin, Rossetti and Madox Brown in particular, they immediately

116 Edward Coley Burne-Jones
The Origins of the Guelf and Ghibelline Quarrel c 1859
Pen and ink. Ashmolean Museum, Oxford
Gualdrada Donati presenting her daughter to Buondelmonte de' Buondelmonti who was already betrothed to another.

became, and have since remained, inextricably involved with the Brotherhood in the minds both of artists and of the public.

Burne-Jones' earliest work is explicitly Rossettian in both style and subject matter (116, 117) which is not perhaps surprising in view of his lack of formal artistic training, and his close involvement with Rossetti in the late 1850s. Even Morris fell under the spell; in his only surviving oil painting of any importance (118) he has also produced a Rossettian image, and both of them were to remain Rossetti's close friends and associates until his death.

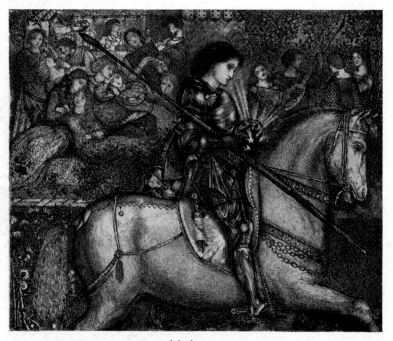

117 E.Burne-Jones *Sir Galahad* c 1857
6″ × 7½″ Fogg Art Museum, Cambridge, Mass.
Greville L.Winthrop Bequest

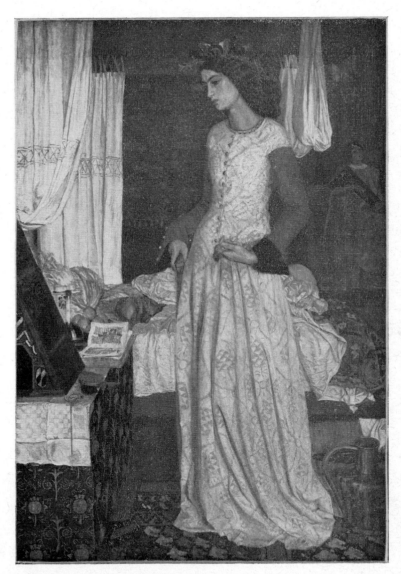

118 William Morris *Queen Guinevere* 1858
$28\frac{1}{2}'' \times 19\frac{3}{4}''$ Tate Gallery, London

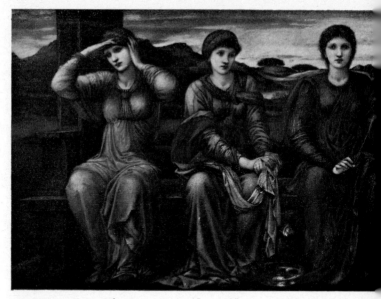

119 E.Burne-Jones *The Hours* 1882 $30\frac{1}{2}'' \times 72\frac{1}{4}''$

Morris, a wealthy man of enormous energy and versatility was however to provide the means for both Burne-Jones and himself to develop away from the Pre-Raphaelite tradition. Profoundly interested and involved in socialism, in poetry and in design, he was largely responsible for the establishment of 'The Firm' of Morris, Marshall, Faulkner and Co. Initially founded to design and manufacture furniture for Morris' new Red House in 1860, it soon became an extremely successful and influential producer of fabrics, furniture and stained glass windows, the vast majority of the latter being designed by Morris and Burne-Jones together (120) or separately (121, 122). Individually they are impressive works, and the best of them (e.g. those in St Philip's Cathedral, Birmingham) stand comparison with the finest mediaeval work

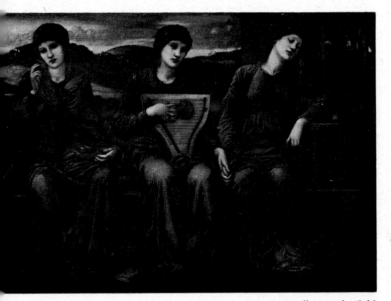

City Art Galleries, Sheffield

in their originality of conception, unity of design and subtle clarity of colour. Cumulatively—and some 450 separate designs were produced—they provided a medium ideally suited to the expression of Burne-Jones' individual genius. The insubstantial grace of the figures and the delicate modulation of the colours which are so apparent in Burne-Jones' paintings, and the vertically divided compositions which he so often favoured, are all a result of his work in stained glass (119, 122).

The influence of Rossetti never altogether disappeared—there is an introspective intensity and claustrophobia in all Burne-Jones' work and indeed he remarked after Rossetti's death that he knew even better than Rossetti did himself what he wanted to paint; but other influences are at work as well. Burne-Jones was

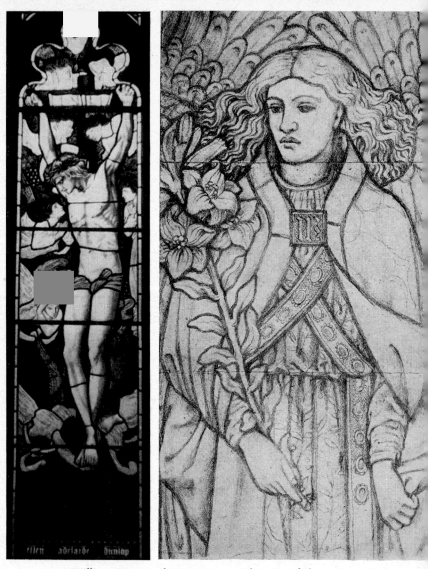

120 William Morris and E.Burne-Jones *Christ Crucified* 1873
Stained glass, Jesus Chapel, Troutbeck, Westmorland

121 William Morris *The Archangel Gabriel* 1862 chalk $21\frac{5}{8}'' \times 11\frac{3}{8}''$
Whitworth Art Gallery, University of Manchester
Design for a stained glass window in St Michael's, Brighton

122 E.Burne-Jones *The Garland* 1866
Watercolour and body colour 30″ × 17″ Private Collection
A painting used as a design for a stained glass window in the dining
room designed by 'The Firm' for the Victoria and Albert Museum

123 E.Burne-Jones *Summer Snow* 1863
Engraving $5\frac{3}{4}'' \times 4\frac{1}{4}''$
Published under the name Christopher Jones in *Good Words*,
accompanying an anonymous poem

among the few Pre-Raphaelites ever to visit Italy and he clearly admired the tense linear rhythms of Botticelli (newly appreciated in the mid-nineteenth century) and Mantegna, though his taste was catholic, and he copied paintings by Titian and Veronese and antique bas-reliefs as well. Evident too in his early drawings and his wood engraving *Summer Snow* (123) is his interest in early German engravings; 'wood engraving', he wrote is 'about the noblest calling on earth', and 'by absolutely perfect wood engraving I mean such work as all the sixteenth-century engravings'. 'Of course', he lamented, people will generally prefer 'the ignominious wooliness and prettiness of Birket Foster', and even Millais had produced 'scribbly work' which 'enrages one beyond description'. 'In engraving,' he wrote in 1862, 'every faculty is needed: simplicity, the hardest of all things to learn, restraint, leaving out every idea that is not wanted (and perhaps fifty come where five are wanted), perfect outline . . ., and a due amount of quaintness.'

In his later work, which gained for him an international reputation, higher perhaps than any English artist had previously enjoyed, the disposition of masses within space—until the paintings were conceived in almost abstract terms as assemblages of colour and light—became more important to him than the linear patterns of his early work. But it was Burne-Jones'

124 John Melhuish Strudwick, detail from *A Golden Thread* 1885
Tate Gallery, London

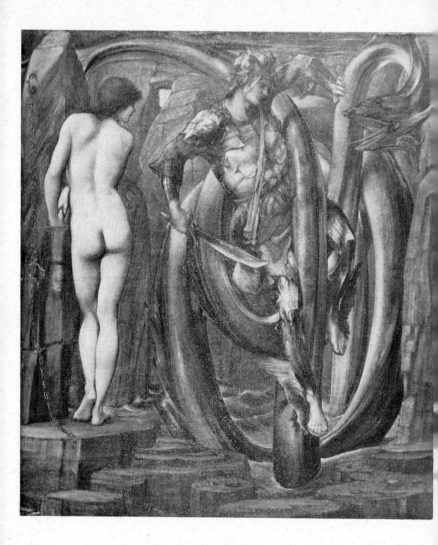

125 E.Burne-Jones *Perseus Slaying the Serpent* c 1885
Gouache $60\frac{1}{2}'' \times 54\frac{1}{2}''$ City Art Gallery, Southampton
This composition bears an interesting resemblance to Ingres'
Ruggiero and Angelica (48)

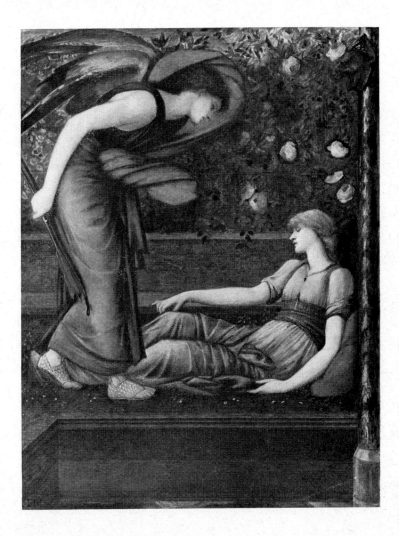

126 E.Burne-Jones *Cupid and Psyche* c 1870
Watercolour and bodycolour $25\frac{1}{2}'' \times 19\frac{1}{4}''$ City Art Gallery,
Manchester

repetitive linear technique, and the sinuous forms of his andro-gynous figures from the myths and legends which he fanatically loved (125, 126) which were to stimulate a whole generation of English artists into attempted emulation. J.M.Strudwick(1849–1935) his studio assistant (124), and Walter Crane (1845–1915) were perhaps the most accomplished of these followers, but their work already betrays a febrile and exaggerated mannerism which in the hands of less accomplished artists easily devolved into farce.

Morris' own contribution to Pre-Raphaelitism was hardly less in his role as entrepreneur than as designer, for in 1891 he established The Kelmscott Press in order to print books which Burne-Jones would illustrate, again giving the artist prolific opportunities to express his dreamlike and magical vision of the world as it never was. The socialist intentions of Morris' business enterprises were to some extent vitiated however by the expense of his productions, and though his floral designs for fabrics and wallpapers, and his simple practical chairs have influenced design thinking ever since, and are central to any consideration of his achievement, they are only most tenuously related to the revolt of 1848 against the orthodoxy of the Royal Academy.

Much more closely reminscent of the original Pre-Raphaelite aims was Morris' romantically direct and simplistic poetry, and it was in the literary world of the Aesthetic Movement in the 1880s and 1890s that Pre-Raphaelitism was last of any real account. It was not Morris, however, but Swinburne and Wilde who were the luminaries, and it is not unfair to draw an analogy between their work and that of Aubrey Beardsley (1872–98). The latter, engaged by Dent and Co. to illustrate *Le Mort d'Arthur*, hopefully in the style of Burne-Jones, developed and caricatured that streak of sensuous evil and menacing self indulgence which had been present in the movement from the beginning in the work of Hunt and Rossetti, and latterly in that of Sandys and Simeon Solomon (1840–1905), a friend of Swinburne's and like him a flagrant and extravagant flouter of the conventional moral norms of late Victorian society. *Withered Spring* (127), originally drawn as an illustration to the Malory, but only used in a modified form, provides a grotesque, organic code to the Pre-Raphaelite move-ment. Its inspiration is manifest, but so is its mockingly self-aware representation of a degenerate and decaying ideal.

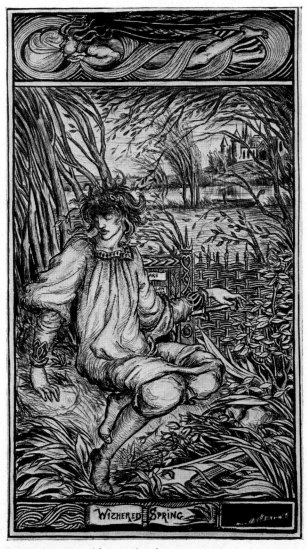

WITHERED SPRING

127 Aubrey Beardsley *Withered Spring* c 1892
Indian ink and pencil 12" × 8¾"
National Gallery of Art, Washington D.C.
Rosenwald Coll.

Acknowledgements

This book has not sought to do more than provide a general introduction within a broadly chronological framework to one of the most fascinating and complex of all artistic movements. It cannot, of its nature, help but be substantially dependent on the work of others, and those familiar with the field will easily recognise my debts to previous writers. Those to whom I owe most are listed in the *Selective Bibliography* opposite.

Many people have helped and encouraged me in my work, and I should like especially to thank Christine Bernard, Susan Booth, John Gordon-Christian, Mark Haworth-Booth, Peter Howell, John Rhodes, Allen Staley and Mrs Virginia Surtees. For my parents' encouragement and enthusiasm I shall always be grateful, but my greatest debt is indicated by the book's dedication. If it helps or encourages anyone to look at the Pre-Raphaelite paintings and drawings which are to be seen in most of the art galleries of the English-speaking world, it will have been worth while.

All pictures are reproduced by kind permission of the copyright holders, generally the owners. Those in the Victoria and Albert Museum are Crown copyright. The medium is only indicated in the captions to those pictures which are not oil on canvas.

Selective Bibliography

Central to any study of the Pre-Raphaelites is W.E.Fredeman *Pre-Raphaelitism: a Bibliocritical Study* (London/Cambridge, Mass., 1965) which provides a remarkably detailed and valuable discussion of all the important printed works and manuscripts with any bearing on the Brotherhood. R.Ironside and J.Gere *Pre-Raphaelite Painters* (London/New York, 1948) remains the best general survey, supplemented by chapters in T.S.R.Boase *English Art 1800–1870* (Oxford/New York, 1959); Quentin Bell *Victorian Artists* (London/Cambridge, Mass. 1967); Graham Reynolds *Victorian Paintings* (London/New York, 1967) and Jeremy Maas *Victorian Painters* (London/New York, 1969). Percy H. Bate *The English Pre-Raphaelite Painters; Their Associates and Successors* (London, 1899) is still useful. Allen Staley's forthcoming book on Pre-Raphaelite Landscape Painting will probably provide the first extended modern survey of their art. Meanwhile his section of the exhibition catalogue *Romantic Art in Britain, Paintings and Drawings 1760–1860* (Philadelphia/Detroit, 1968) is most valuable.

William Holman Hunt *Pre-Raphaelitism and the Pre-Raphaelite Brotherhood* (London, 1905; second edition 1913, reprinted New York, 1967) is an essential, though misleading, source. The best modern discussion of Hunt is in the catalogue of the Arts Council exhibition *William Holman Hunt* (Liverpool/London, 1969) by Mary Bennett.

Most of Rossetti's letters have been edited by Oswald Doughty and J.R.Wahl *Letters of Dante Gabriel Rossetti* (Oxford/New York, 1965–7). The biography by W.M.Rossetti *D.G.Rossetti: His Family Letters, with a Memoir* (London, 1895) is fundamental, as are W.M.Rossetti (ed) *Ruskin, Rossetti, Pre-Raphaelitism; Papers 1854–62* (London, 1899), W.M.Rossetti (ed) *Pre-Raphaelite Diaries and Letters* (London, 1900), and W.M.Rossetti (ed) *The Germ: A Facsimile Reprint* (London 1901, reprinted New York, 1965). Virginia Surtees *Paintings and Drawings of Dante Gabriel Rossetti* (Oxford/New York, 1970) forms the basis for all future work on the artist. Oswald Doughty *A Victorian Romantic* (London/New York, 1960) and Rosalie Glynn Grylls *Portrait of Rossetti* (London, 1964) are complementary modern biographies.

J.G.Millais *The Life and Letters of Sir John Everett Millais* (London, 1899) and F.M.Hueffer *Ford Madox Brown: A Record of His Life and Work* (London, 1896) are basic sources. More up to date are Mary Bennett's two exhibition catalogues *Ford Madox Brown* (Liverpool/Manchester/Birmingham, 1964) and *J.E.Millais* (Liverpool/London, 1967). The best book on Morris is Paul Thompson *William Morris* (London/New York, 1967) while for Burne-Jones, Georgiana Burne-Jones *Memorials of Edward Burne-Jones* (London, 1904) and Malcolm Bell *Edward Burne-Jones: A Record and Review* (London, 1892) are still the basic accounts.

STUDIO VISTA | DUTTON PICTUREBACKS
edited by David Herbert